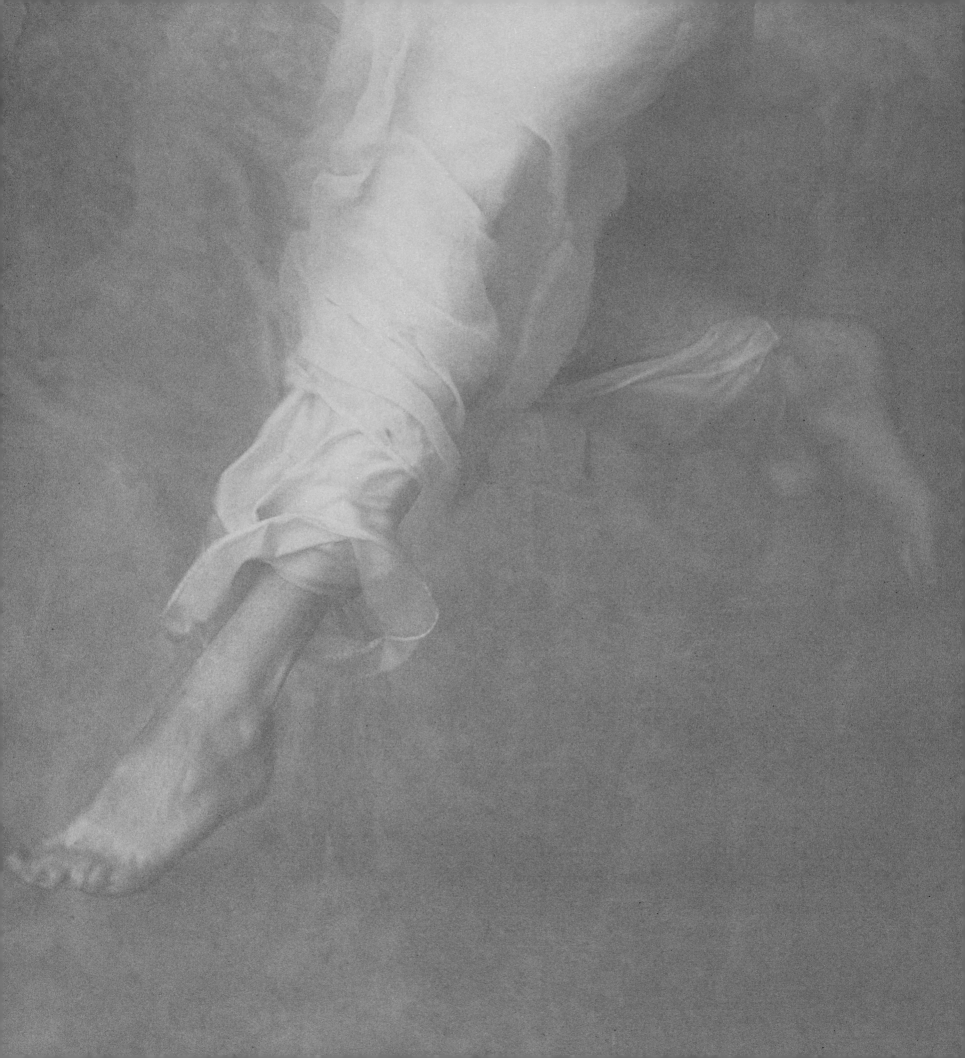

VISIONS OF ANGELS

35 Photographers Share Their Images

S Editions is an imprint of SMITHMARK Publishers.

This edition published in 1998 by SMITHMARK Publishers,
a division of U.S. Media Holdings, Inc.,
115 West 18th Street, New York, NY 10011.

SMITHMARK books are available for bulk purchase for sales promotion
and premium use. For details write or call the manager of special sales,
SMITHMARK Publishers, 115 West 18th Street, New York, NY 10011; 212-519-1300.

Distributed in the U.S. by
Stewart, Tabori & Chang,
a division of U.S. Media Holdings, Inc.,
115 West 18th Street, New York, NY 10011.

Printed in Hong Kong

10 9 8 7 6 5 4 3 2 1

Quotation: Minor White, Mirrors/Messages/Manifestations
©1982, Aperture, Inc.
Endpapers: © Marcia Lippman, Isadora Duncan Dancers, 1996.

Project Director: Elizabeth Viscott Sullivan
Editor: Tricia Levi
Designer: Karen Engelmann/Luminary Books & Design, Dobbs Ferry, NY

VISIONS
OF ANGELS

35 Photographers Share Their Images

NELSON BLONCOURT & KAREN ENGELMANN

Foreword by Sophy Burnham

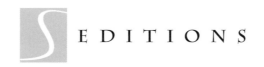

S EDITIONS

FOREWORD

They say that to talk of Love is to make love, and to talk of angels is to bring them to us, the spirits of Love. We are filled with love—the very cells of our bodies burning with the fire of their love.

What are angels? The word comes from the Greek, meaning messenger. *They are called* ministers, servants, watchers, the chariots of God. *They are the invisible ones, who come to hold us, heal us, guide us, guard us. They take on any form in which they can be received: as visions, as voices, as dreams, as mysterious accidents or as the weird and marvelous coincidence that leaves us laughing with awe and disbelief. They are the whisper of intuition at our shoulder; we have all experienced this feeling: "I knew I shouldn't have gone down that road but I didn't listen." Sometimes the angel appears in the form of a friend who says exactly the words we need to hear that day. Or you will unknowingly act as an angel to someone else, tossing off a message so casually that, though it saves another person's life, you hardly remember the moment at all.*

And sometimes angels come in their own resplendent form. We see them with the spiritual eye, and everyone who has seen an angel uses the same words to describe what they experienced. They speak of radiance, light, warmth, refulgent beauty, joy, love, majesty, magnificence. There are three marks of an angel's work. First, they always say: "Don't be afraid. We're here. We're taking care of things." Second, you are filled with warmth and joy. Home! *cries your lost and lonely soul, flooding with remembrance. Third, you are never quite the same: you cannot forget.*

But what do they look like? We catch a glimpse from the corner of an eye, and when we turn they are gone. "Was it our imagination?" we wonder. They are seen as male or female, with wings of every color or without any wings at all. They appear as babies—cherubs—or as giants big as jumbo jets. They come as splendid warriors armed with flashing swords or as gentle, girlish, barefoot beings, luminous in white. Their eyes are pools of love.

Afterwards, you cannot stop thinking of what you saw. You do not speak of it immediately but hold the vision to your heart. "Why to me?" you ask, humbled before the suffering of this world and by the touch of such unfathomable love. You are silent before the mystery of angels.

All around us lie these mysteries: the stars at night, tulips bursting through the earth in spring, the miracle of a newborn baby's cry, of water (flowing or frozen), and of the air we breathe. Among the mysteries, choirs of angels are aiding us—now seen, now gone, but crying with one voice, "Fear Not. We're Here. Give Praise and Joy! Give Love! Give Thanks."

This beautiful book celebrates the wonder and mystery of angels—and brings Love closer to us all.

SOPHY BURNHAM

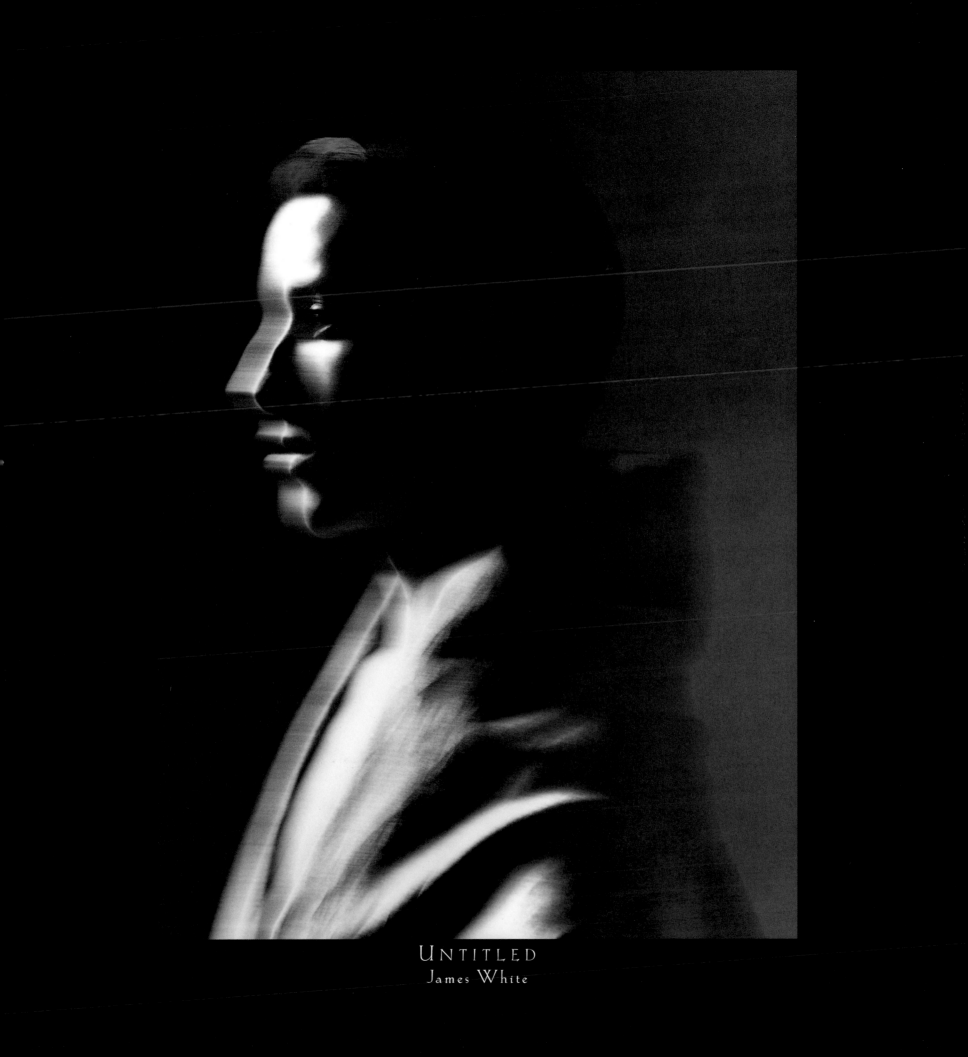

UNTITLED
James White

AN INTRODUCTION

The idea for this book did not come from me. Rather, it came through me. Some may call it divine inspiration, an epiphany, or perhaps even a visitation. I say it's something that happens each moment to every one of us. Creation speaking. For a change, I chose to listen and act.

I had recently moved to the Santa Fe area after almost 20 years as a photographer's agent in New York City. A colleague had asked me, "What are you going to do now?" I didn't have an answer. An hour later, driving up a dirt road in the foothills of the city, I heard these words: "Nelson, what you are going to do is create a book of photographs of angels." I thought, okay, I can do that. I waited for more instructions. None came.

The next day, I called my friend Karen Engelmann, and before I'd finished telling her about the idea, she had agreed to take part. The project was born. That was Friday, July 1, 1995.

The process has been an amazing and sometimes overwhelming one, from the voice that first instructed me, to sleepless nights filled with hosts of angels calling out their names. I visited atelier studios and galleries, searched through books and magazines, received tips from friends by phone, fax, and courier. Through all these means, the images appeared.

I have pored over hundreds of photographs and talked to dozens of photographers about these earthbound heavenly messengers. Stacks of books from every religious tradition contained the names that provide commentary and meditation. Many of the names are obvious in their reference to each image. Some are Karen's and my personal interpretations of these visions. I have been happy and honored to be immersed in the energy and guidance of these wonderful spirits. And I am inspired by the work of the talented artists who have captured them. I am immensely grateful to them all for making this a reality.

I offer this book to you in trust that you will agree that angels are among us. Perhaps a neighbor. Maybe you. Maybe me.

NELSON BLONCOURT
SAN FRANCISCO, 1998

"No matter how slow the film,
Spirit always stands still long enough
for the photographer It has chosen."

—MINOR WHITE
Mirrors/Messages/Manifestations

FURLAC
Angel of the Earth

CHAROUTH
Angel Who Runs Through Heaven and Earth

ZI'IEL
Angel of Commotion

CARCAS
Angel of Confusion

MISRAN
Angel of Persecution

FEET, 1987
David Seidner

ZAVAEL
Angel of Whirlwinds

ISRAFEL
Angel of Resurrection

BLAEF
Angel of the Air

EZRAEL
Angel of Wrath

HAATAN
Angel of Concealed Treasures

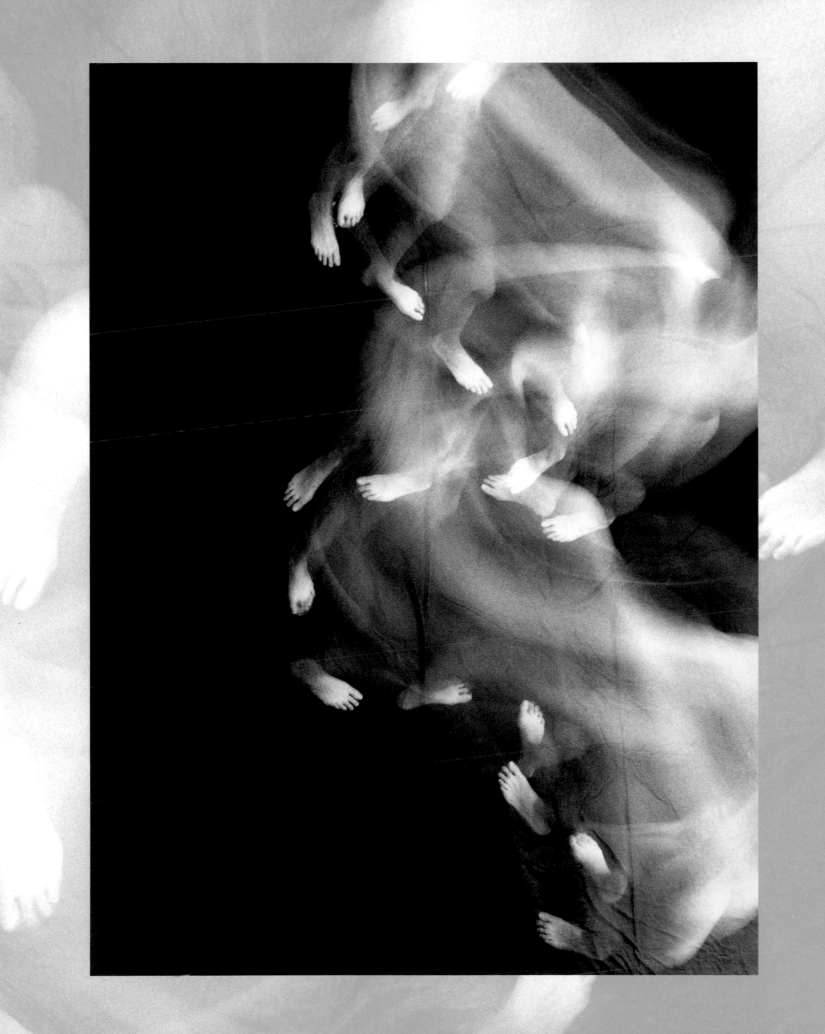

RAPHAEL
Angel of Healing

APUTEL
Reviver of the Dead

PABAEL
Spirit Messenger of the Moon

JIBRIL
Mightiest of Angels

ARZAL
Angel of Secret Wisdom

DESCENDING ANGEL
John Wimberley

GETHEL
Angel of Hidden Things

JERAZOL
Angel of Power

BAGDIAL
Angel Who Issues Cards for New "Bodies"

CURETON
Holy Angel of God

TOTRISI
Angel of the Sword

HYPERACHII
Archangels Who Guide the Universe

ALPIEL
Angel Ruler of Fruit Trees

ZAFRIRE
Morning Spirits

PSYCHOPOMPOI
Soul-Escorting Angels

RIBBOTAIM
God's Chariot Angels

GOSSAMER, 1996
Marcia Lippman

BARUCH
Chief Guardian Angel of the Tree of Life

ZUPHLAS
Angel of Forests

ARIAS
Angel of Sweet-Smelling Herbs

COMMISSOROS
Angel of Spring

ANAHITA
Angel of Earth's Fruitfulness

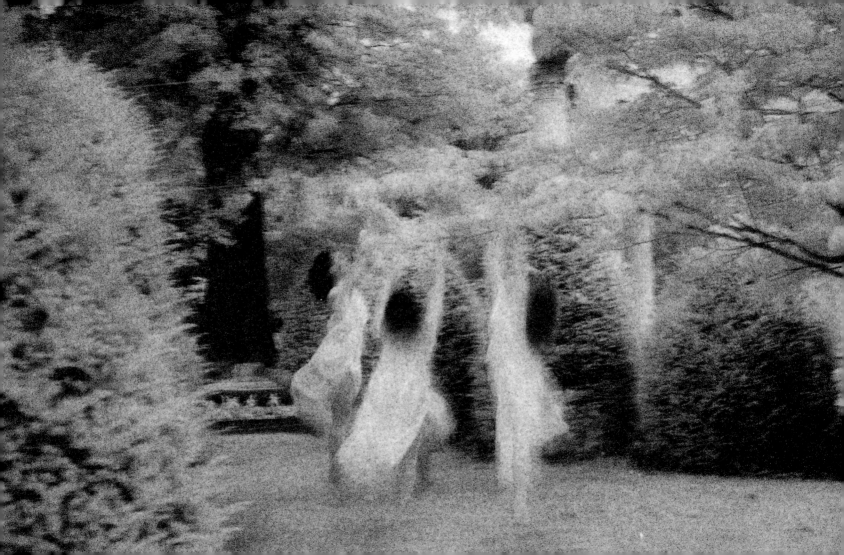

UR
Angel King of the Netherworld

CASSIEL
Angel of Solitude and Tears

MASTHO
Angel of Delusive Appearance

VAMONA
Angel of Reason

ADAM
The Bright Angel

SERIES 5, 1992–94
Robert Stivers

SAURIEL
Angel of Death

URIEL
Angel of the Abyss

AMOIAS
Angel of the Secrets of Creation

TIPHERETH
Angel of Beauty

RAZIEL
Angel of the Secret Regions

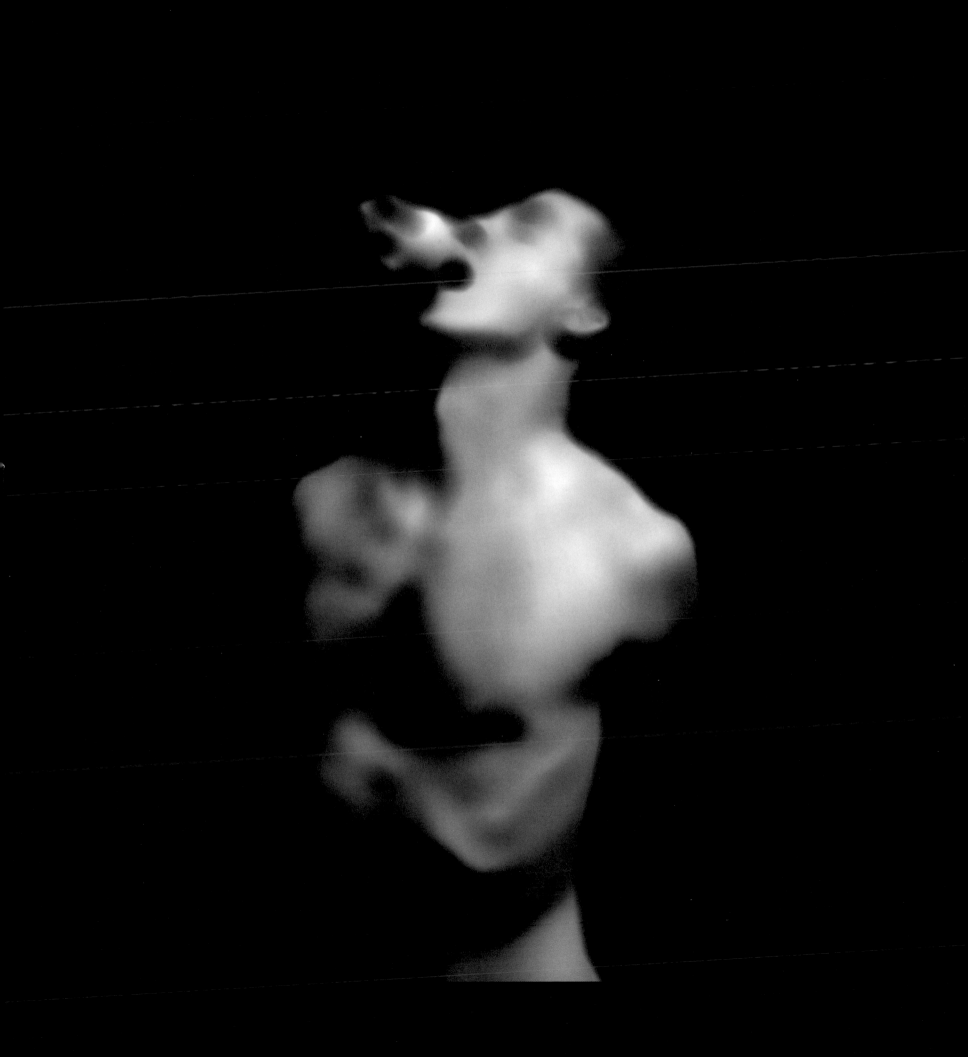

MAH
Angel of the Moon's Phases

MOAKIBAT
The Recording Angel

ONAFIEL
Angel of the Moon

THAMY
Angel of the Order of Powers

CETARARI
Angel of Winter

A FAR CRY FROM HOME, 1995
Richard Di Nome

OCH
Angel of Alchemy

TALIA
Angel who Accompanies the Sun

ZARALL
Angel of the Ark of the Covenant

SEDEKIAH
Treasure-Finding Angel

RUBIEL
Angel of Chance

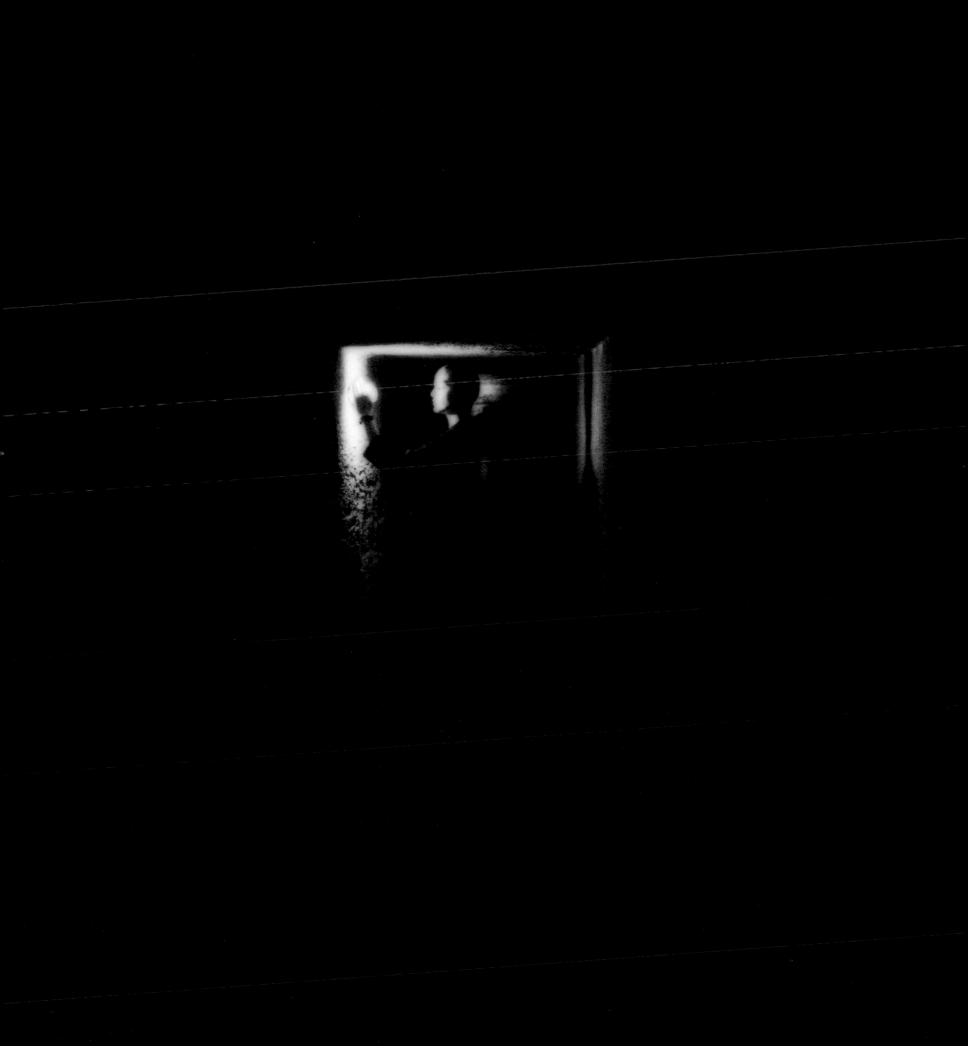

LAHATIEL
Angel of Punishment

PAHADRON
Angel of Trembling

LEMANAEL
Angel of the Moon

NARCORIEL
Angel of the Eighth Hour of Night

THAGRINUS
Angel of Confusion

MICHELE·BACK, 1994
Jack R. Lindholm

EREMIEL
Angel Who Watches Over Souls in the Underworld

SGRDTSIH
Angel Who Ministers to the Son of Man

CAMAYSAR
Angel of the Marriage of Contraries

ZAROBI
Angel of Precipices

SAMAX
Chief Angel of the Air

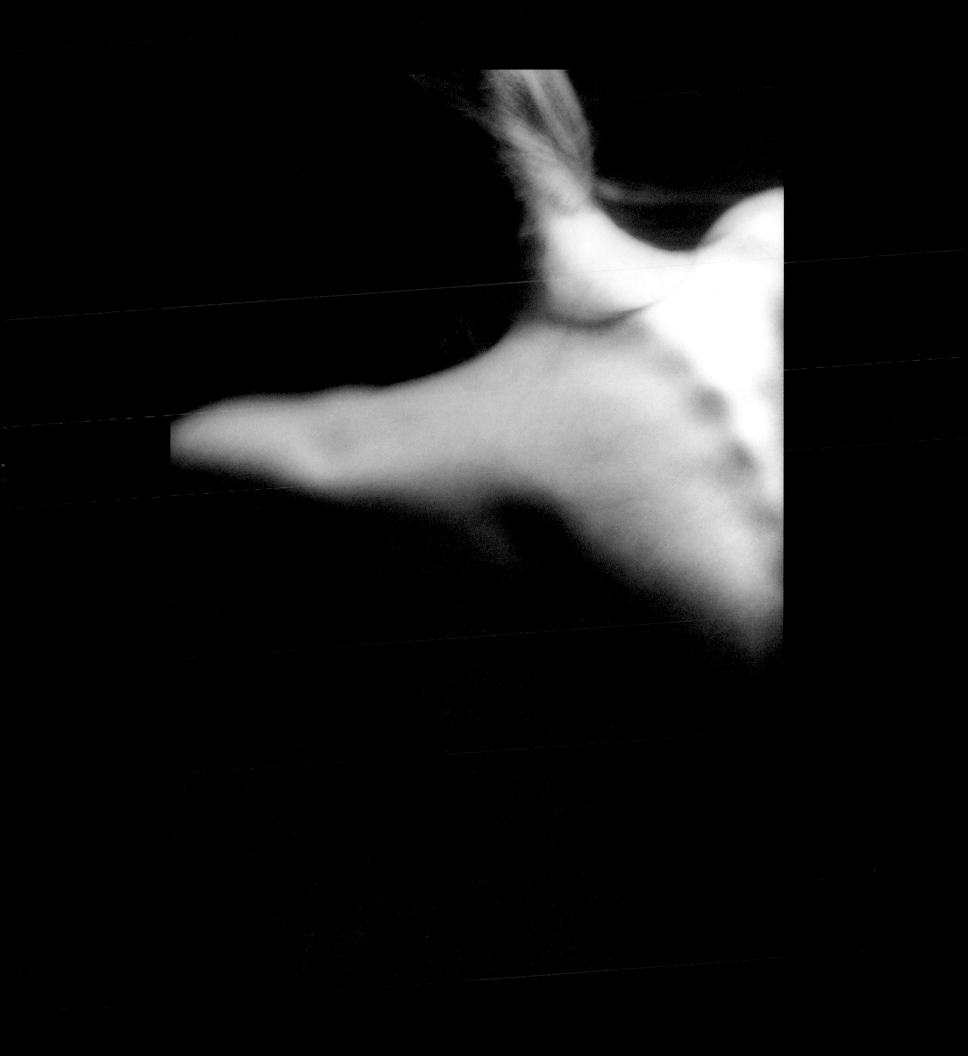

ARATHRON
Angel of Alchemy, Magic, and Medicine

ISPHAN DARMAZ
Angel of Virtuous Women

GADRIEL
Angel Who Crowns Prayers

EBUHUEL
Angel of Omnipotence

BERNAEL
Angel Commanding the Gift of Invisibility

PARTING III, 1983
Chuck Henningsen

SEREDA
Angel Who Washes Away the World's Colors

MANU
Angel of Destiny

PANCIA
Angel of the Sword

CORAT
Angel of the Sun

OUESTUCATI
Angel of the Sea Winds

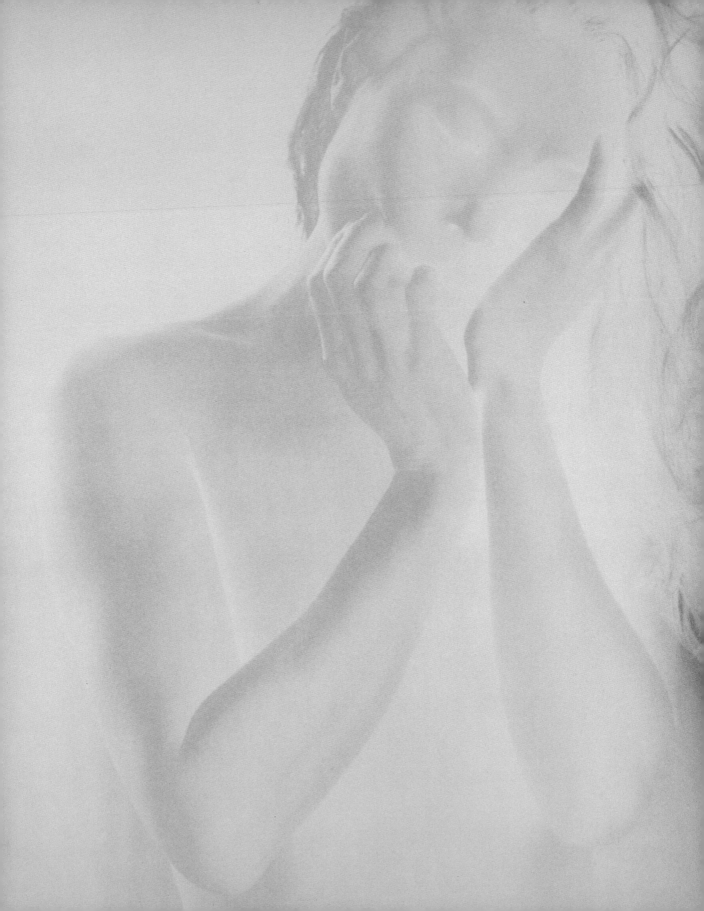

LAILA
Guardian of Spirits at Birth

MANAH
Angel of Fertility

ISDA
Angel of Nourishment

JEKUTIEL
Angel of Childbirth

TEMELUCH
Protector of Infants

TWO FEET PLUS ONE
Joyce Tenneson

SELDAC
Angel of Heavenly Baptism

OMAEL
Multiplier of Species

AKRIEL
Angel of Barrenness

CHASKIEL
Angel of the Childbed

ANANCHEL
Angel of Grace

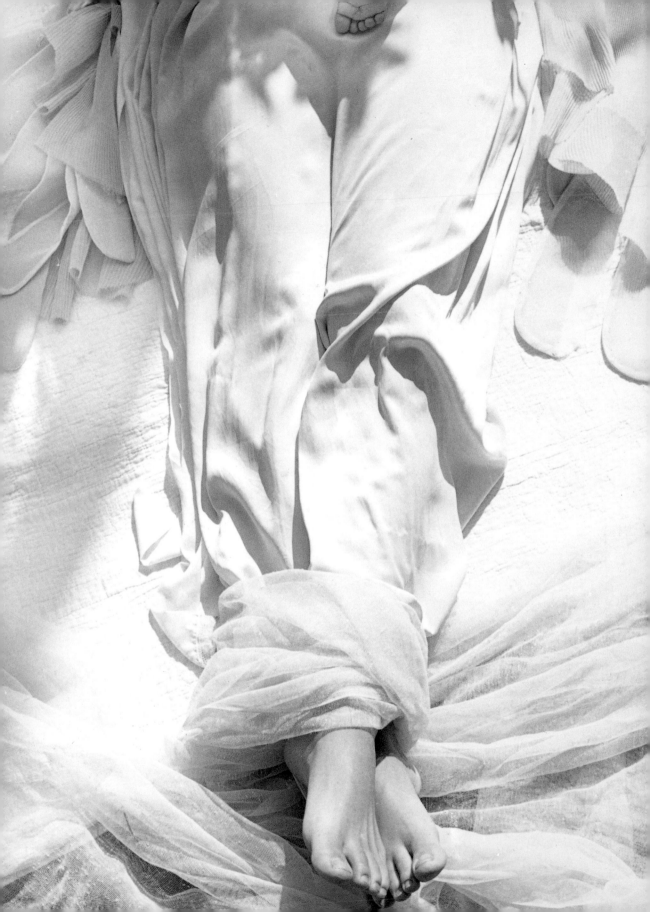

BAGLIS
Angel of Balance

CADAT
Angel of Purity

OFIEL
Angel of the Childbed

RAB-UN-NAW
Angel of Light

AHAVIEL
Angel Who Wards Off Evil

19 MARLENA'S FEET, 1994
Sandi Fellman

ZUMIEL
Angel of the Childbed

MEFATHIEL
Opener of Doors

ISIAIEL
Angel of the Future

MICHEU
Angel of the Waters of Life

ZEHANPURYU'H
Dispenser of Divine Mercy

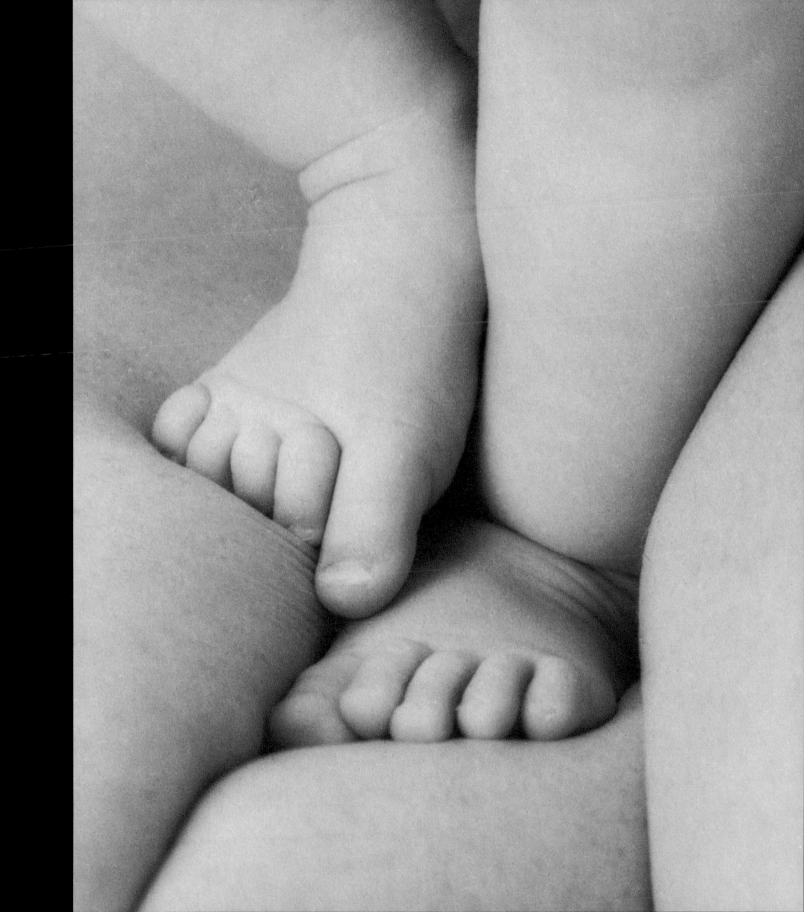

MORIEL
Angel of Awe

JOEL
Angel of Naming

YEFEFIAH
Angel Prince of the Torah

SHEKINAH
Liberating Angel

HARAHEL
Angel of Archives

THE DROWNED, 1988
Audrey Bernstein

PARAQLITOS
Angel of the Sorrows of Death

URZLA
Angel of the East

KEZEF
Angel of Death

SERUF
Angel of Fire

MATARIEL
Angel of Rain

YAASRIEL
Angel of the Seventy Holy Pencils

PENEMUE
Teacher of Writing with Ink and Paper

DABRIEL
Recording Angel

SARGA
Heavenly Scribe

STROPHAEOS
Angel of the Secrets of Creation

HANNA ROSE III
Christine Kiebert-Boss

ASHRULYU
Angel President of the Institute of Learning

MUMOL
Angel of Pen and Ink

SIMULATOR
Angel of Ink and Color

PRAVUIL
Scribe of Knowledge

RADURIEL
Angel of Poetry

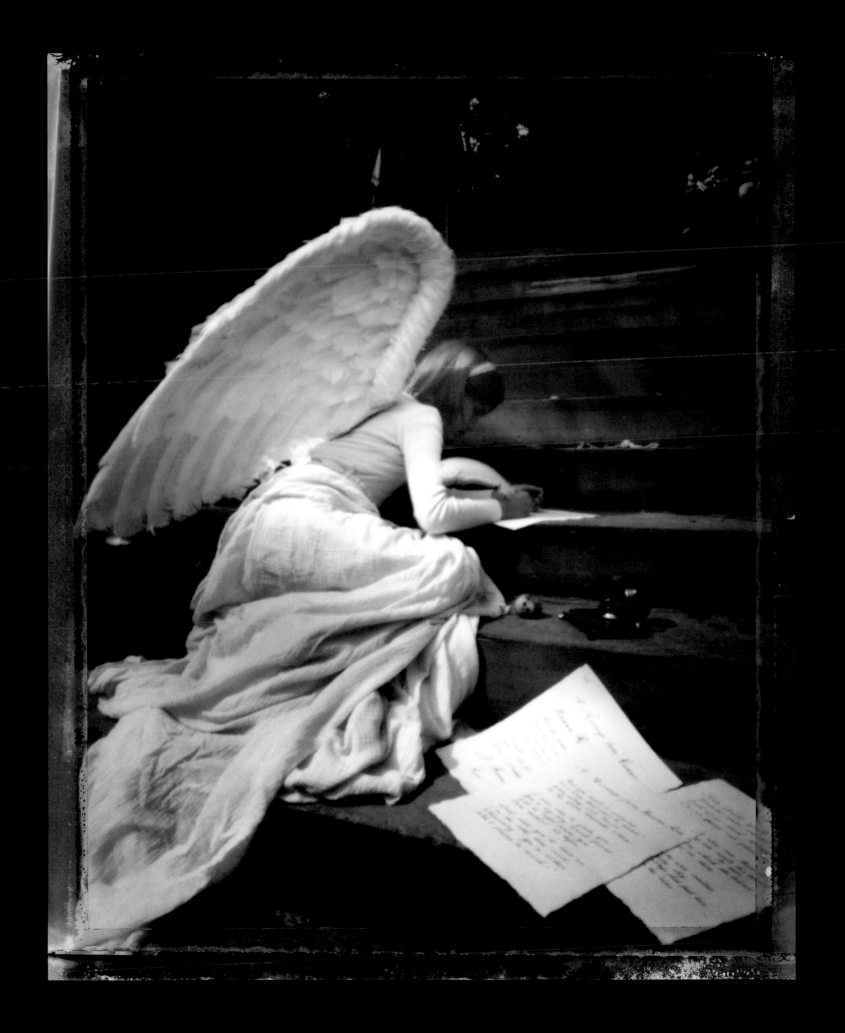

TARFIEL
Angel Invoked to Cure Stupidity

MEHIEL
Protector of Professors, Orators, and Authors

DINA
Guardian Angel of the Law

JESODOTH
Angel of God's Wisdom and Knowledge

ECANUS
Transcriber of Books

UNTITLED
James White

ACHAZRIEL
Usher of the Celestial Court

TEIAZEL
Angel of Librarians

MAROTH
Angel of Tutors and Instructors

POIEL
Angel of Fortune and Philosophy

VRETIL
Keeper of the Sacred Books

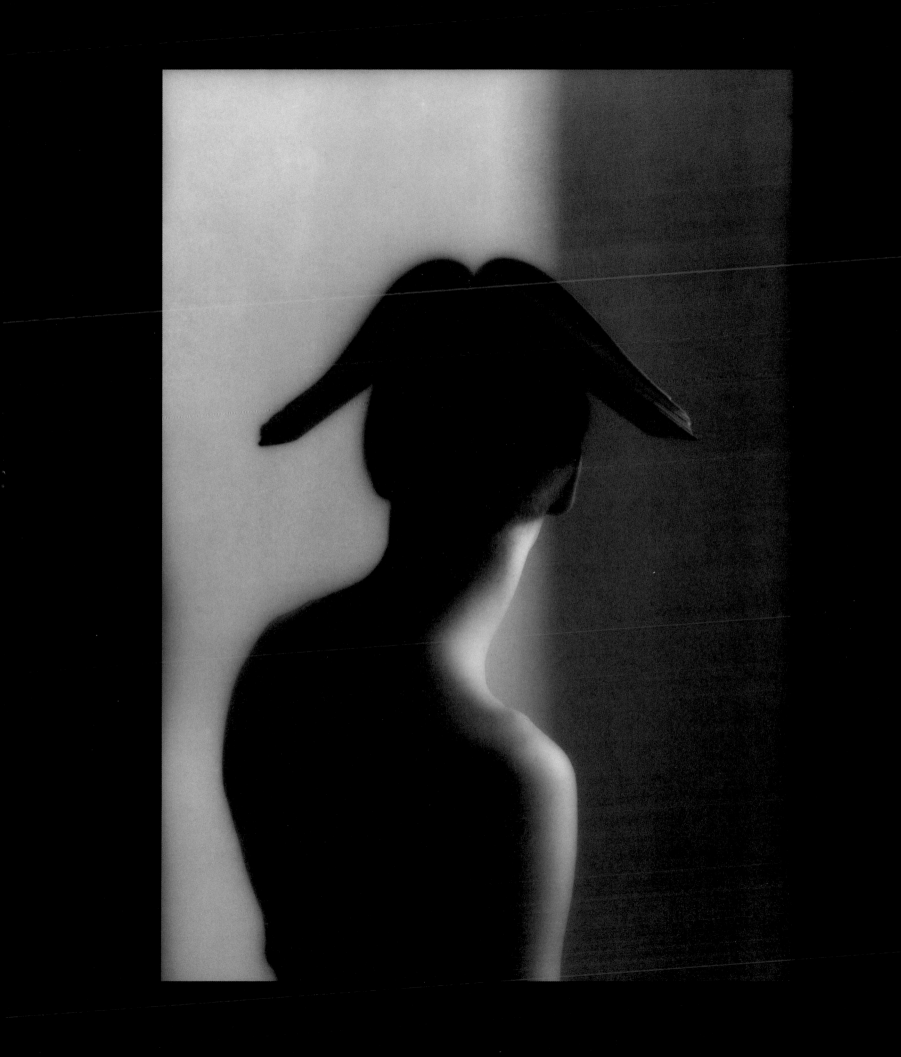

KADRIEL
The Voice of Prophecy

GAMALIEL
Angel Who Draws the Elect to Heaven

EL-ADREL
Angel of Music

SAGNESSAGIEL
Angel of Wisdom

JEDUTHUN
Master of Howling

RANDALL JAYNES 1995
Carolyn Jones

GAVREEL
Angel Who Keeps Insanity at Bay

SAMMAEL
Angel of Mars

AF
Angel of Anger

KUTIEL
Angel of Divining Rods

SIKIEL
Angel of the Sirocco

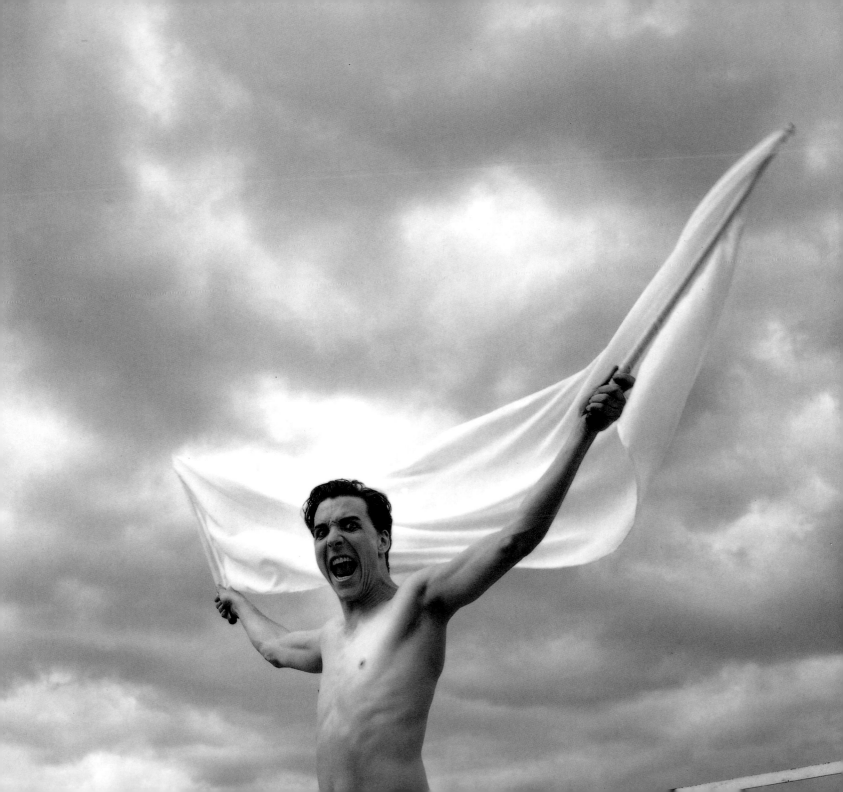

RAAMIEL
Angel of Thunder

RAMAMEL
Angel of the Gates of the East Wind

BEALPHARES
The Noblest Carrier

SAHAQIEL
Angel of the Sky

MIZGITARI
Angel of Eagles

SAN JUAN EAGLE DANCER #1, 1993
David Michael Kennedy

NISROCH
Angel of the Principalities—The Great Eagle

CAPHRIEL
A Strong and Powerful Angel

RABIA
Angel Who Accompanies the Sun

ZERUCH
Angel of Strength

AZARKHURDAD
Closest to the Just God

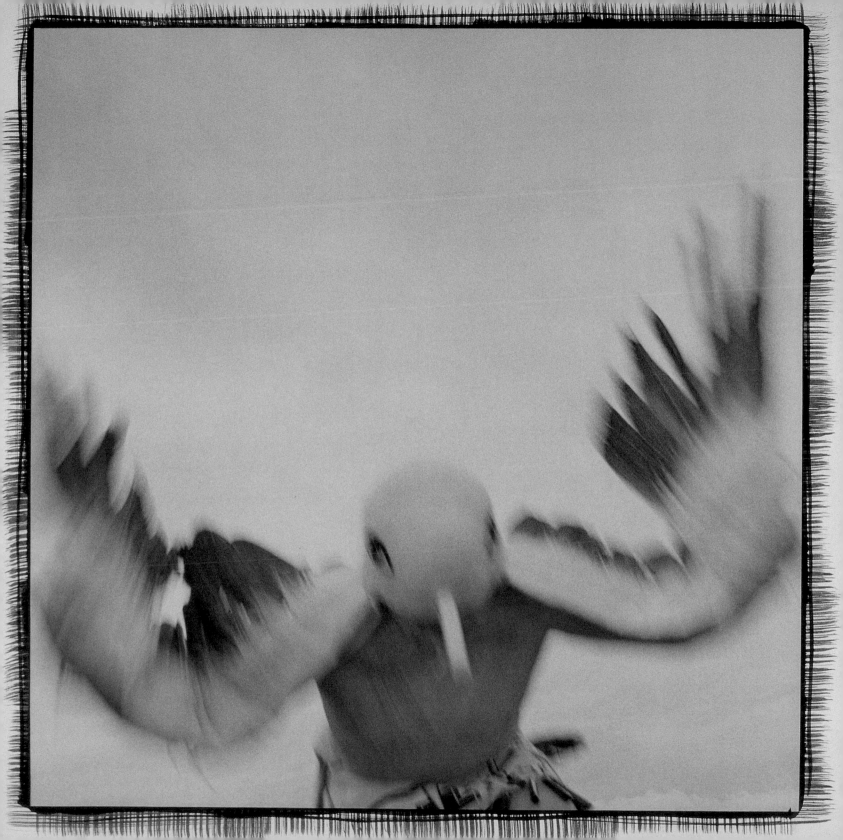

ALPHUN
Angel of Doves

SERAQUIEL
Strong and Powerful Angel

JEFFRIEL
Angel of Modern Dance

MINIEL
Angel Who Can Induce Love in a Reluctant Maid

TAFTIAN
Wonder-Working Angel

ARTHUR AVILES, 1993
Lois Greenfield

AMPHAROOL
Angel of Flight

SHALGIEL
Angel of Snow

MAMMON
King of the Saturday Angels of the Air

SAKNIEL
Angel Guard of the West Wind

ARAEL
Angel of Birds

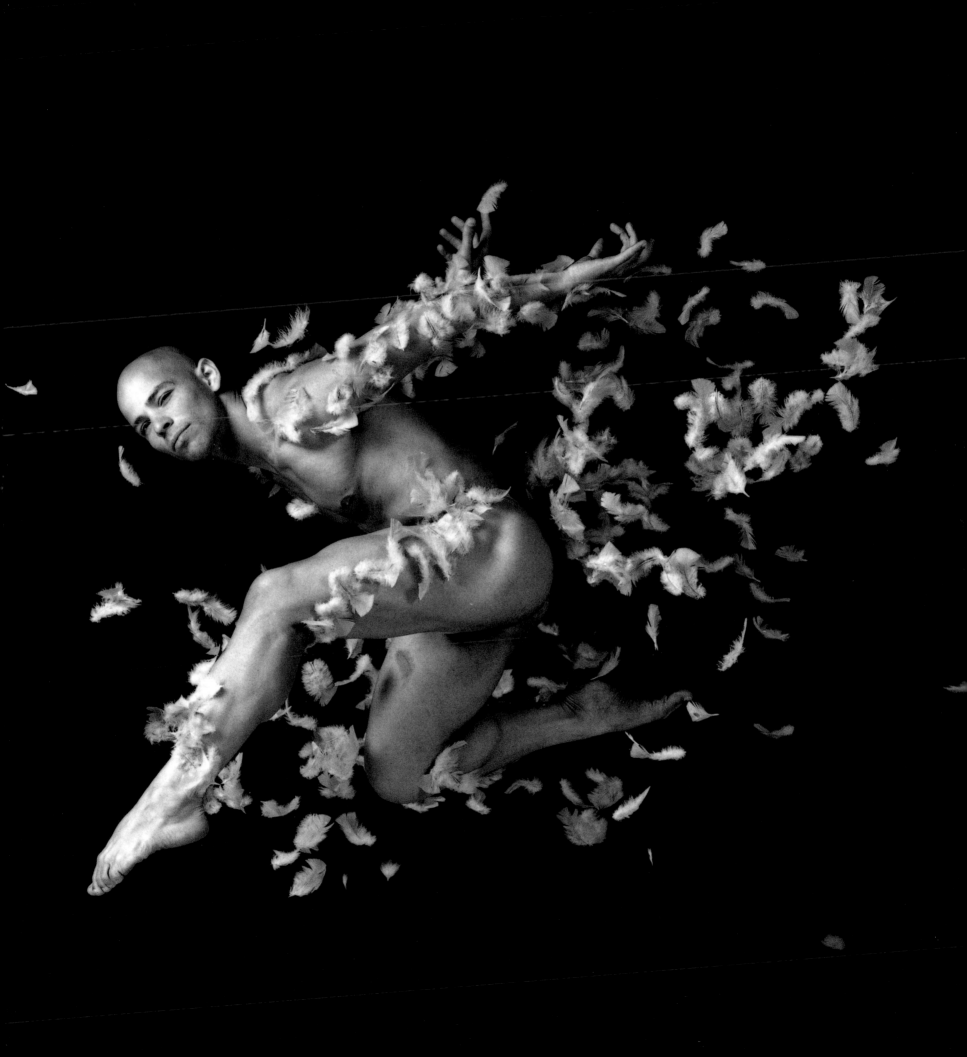

CAUSUB
Serpent-Charming Angel

EZEQEEL
Angel of the Knowledge of Clouds

LABUSI
Angel of Omnipotence

CHERUBIEL
Angel Chief of Cherubs

TETRA
Angel of the Fulfillment of Desire

JAULA DE TERNURA, 1993
Luis Gonzalez Palma

ARMAROS
Angel of Enchantments

SEHEIAH
Angel of Longevity

NAADAME
Angel Prince

BEBUROS
Angel of the End of the World

DOMINION
The Oldest Angel

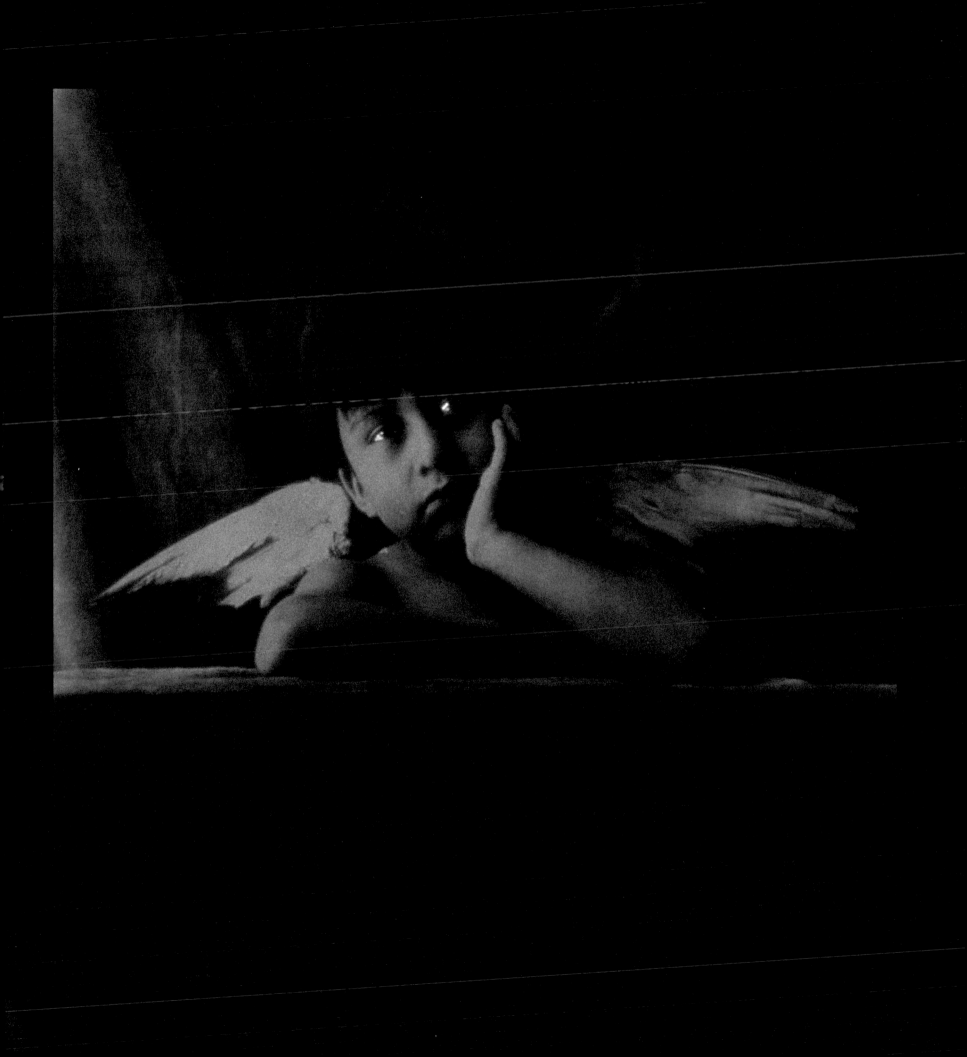

CHERUBIM
God's Charioteers

SERAPHIM
Angels of Love, Light, and Fire

THRONES
Angels of Justice

DOMINATIONS
Regulators of Angelic Duty

BENE ELIM
Angels Who Sing the Praises of God

UNTITLED
Cheryl Koralik

POWERS
Angels of the Heavenly Pathways

ANIM
Many-Eyed Angels

VIRTUES
Angels of Miracles

PRINCIPALITIES
Protectors of Religion

INNOCENTS
Angels of the Celestial Hierarchy

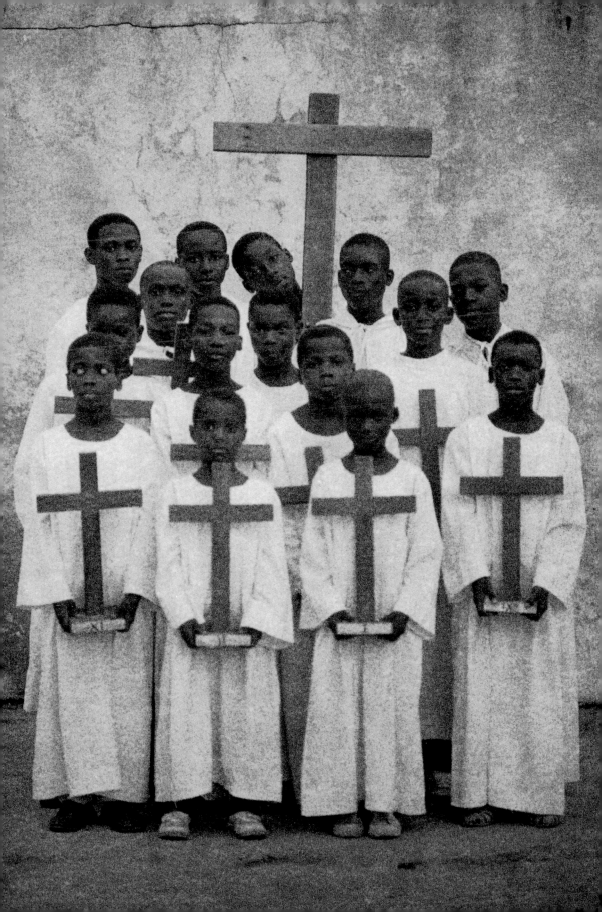

PESAGNIYAH
Angel of the Keys to Ethereal Space

ORIEL
Angel of Destiny

SURIEL
Angel of Healing

ESERCHIE
Angel Assistant to Moses

ZAGZAGEL
Angel of Wisdom

CHOSEN INDIVIDUALS, 1998
Audrey Bernstein

ZEFFAR
Angel of Irrevocable Choice

VRIHASPATI
Angel of Hymns and Prayers

ITATIYAH
Revealer of Mysteries

SUPHLATUS
Angel of Dust

RACHMIEL
Angel of Compassion

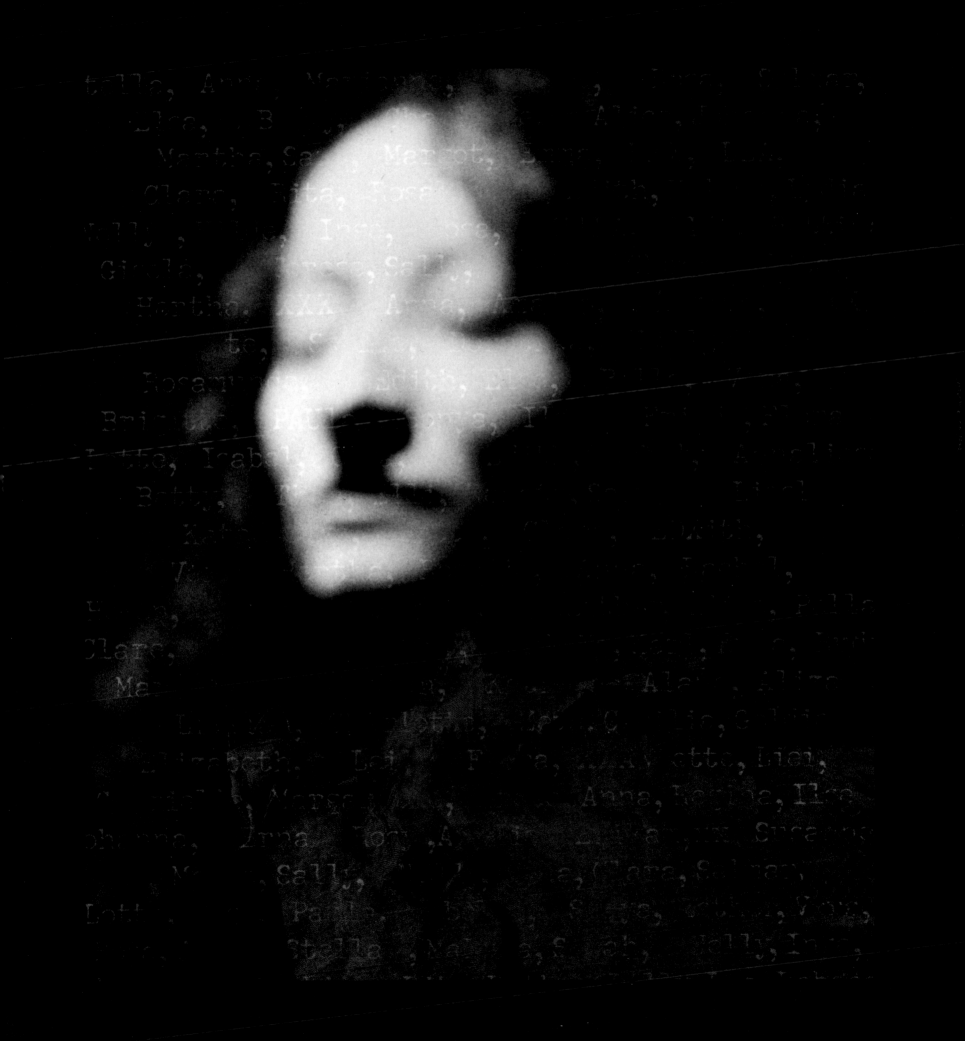

SUSABO
Angel of Voyages

NADIEL
Angel of Migration

MIRIAEL
Angel of Warriors

GADREEL
Angel Who Led Eve Astray

ACHAIAM
Angels of the Secrets of Nature

FERNANDO WITH WINGS, 1993
Blake Little

JEN
Arranger of the Cosmos

RUHIEL
Angel of the Wind

GEBURATHIEL
Angel of Divine Strength

THEGRI
Angel of Beasts

GERMAEL
Angel Sent by God to Create Adam from the Dust

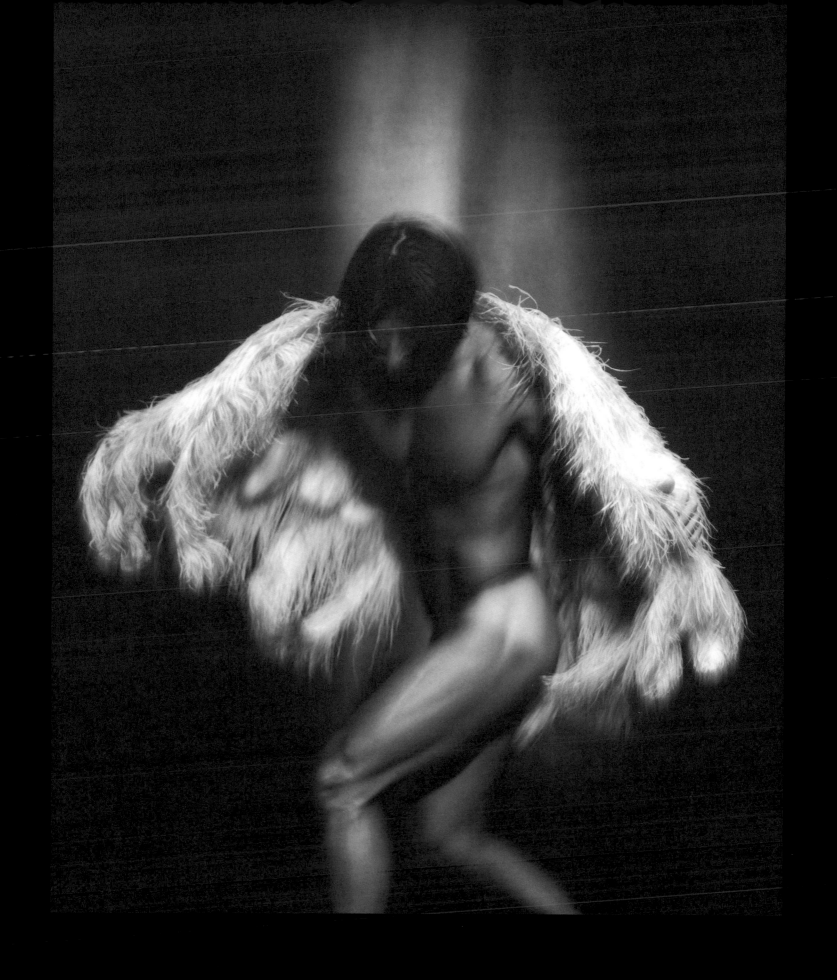

JEREMIEL
Angel of Souls Awaiting Resurrection

NIRGAL
Protecting Angel

CHUR
Angel of the Disk of the Sun

BEN NEZ
Angel of the Wind

SPLENDITENES
Angel Who Supports the Heavens on His Back

JASON, 1995
Kelly Grider

RIDWAN
Angel of the Entrance to the Earthly Paradise

EL EL
Angel Guard of the North Wind's Gate

RAZVAN
Treasurer of Paradise

JUKAR
Prince of All Angels

NEMAMIAH
Archangel Guardian of All Who Support Just Causes

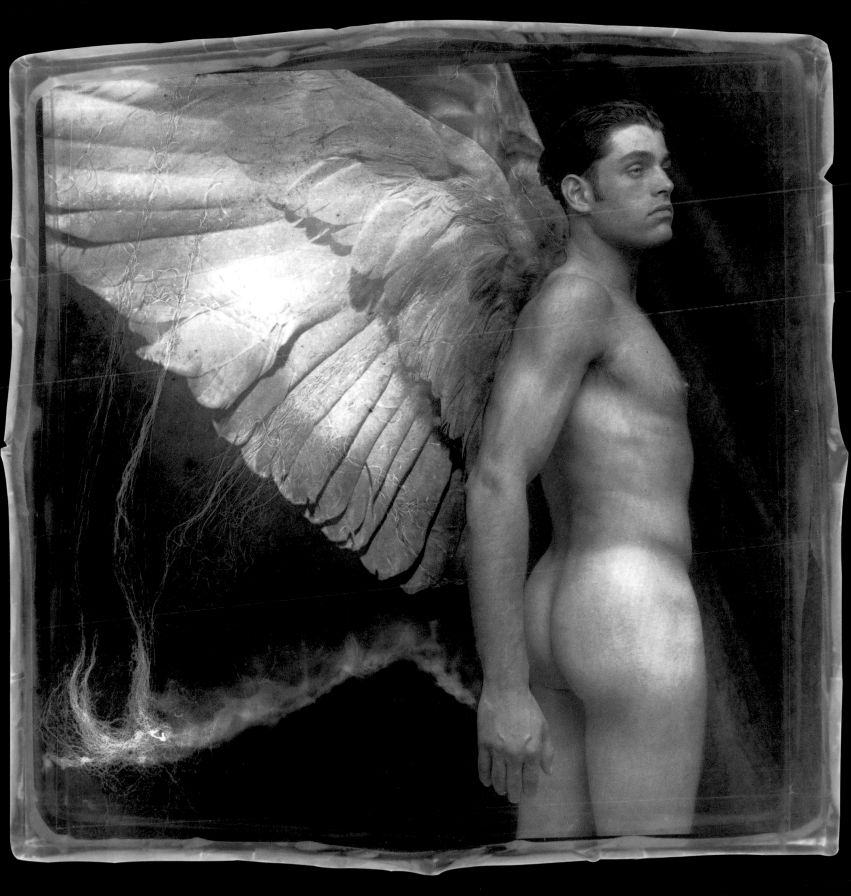

VASSAGO
Angel of Woman's Deepest Secret

SHATEIEL
Angel of Silence

SACHLUPH
Angel of Plants

ZELEBSEL
Angel of the Rainy Season

SEALIAH
Angel of Vegetation

REFLECTION, 1994
Lisa Spindler

CARACASA
Angel of Spring

ATAPHIEL
Angel Who Supports Heaven with Three Fingers

PARASIEL
Angel of Treasures

SOTHIS
Angel of an Hour

CALDULECH
A Most Pure Angel

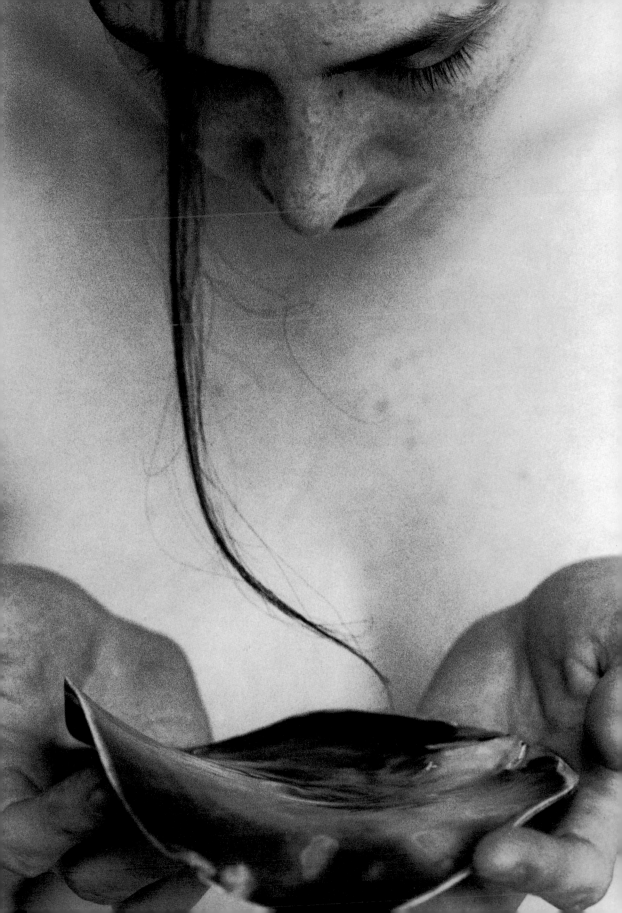

KADRIEL
Angel of Prophecy

RENO
Angel of the Zodiac

LELIEL
Angel Ruler of the Night

URIRON
Angel of Sorcery

IADARA
Angel of Virgo

CRYSTAL BALL, 1994
Andrew Brucker

BARBATOS
Angel Who Knows the Past and Can Foretell the Future

CORAEL
Angel of the Fulfillment of Desire

SIZOUZE
Angel of Prayer

TERATHEL
Angel of Light

EISTIBUS
Angel of Divination

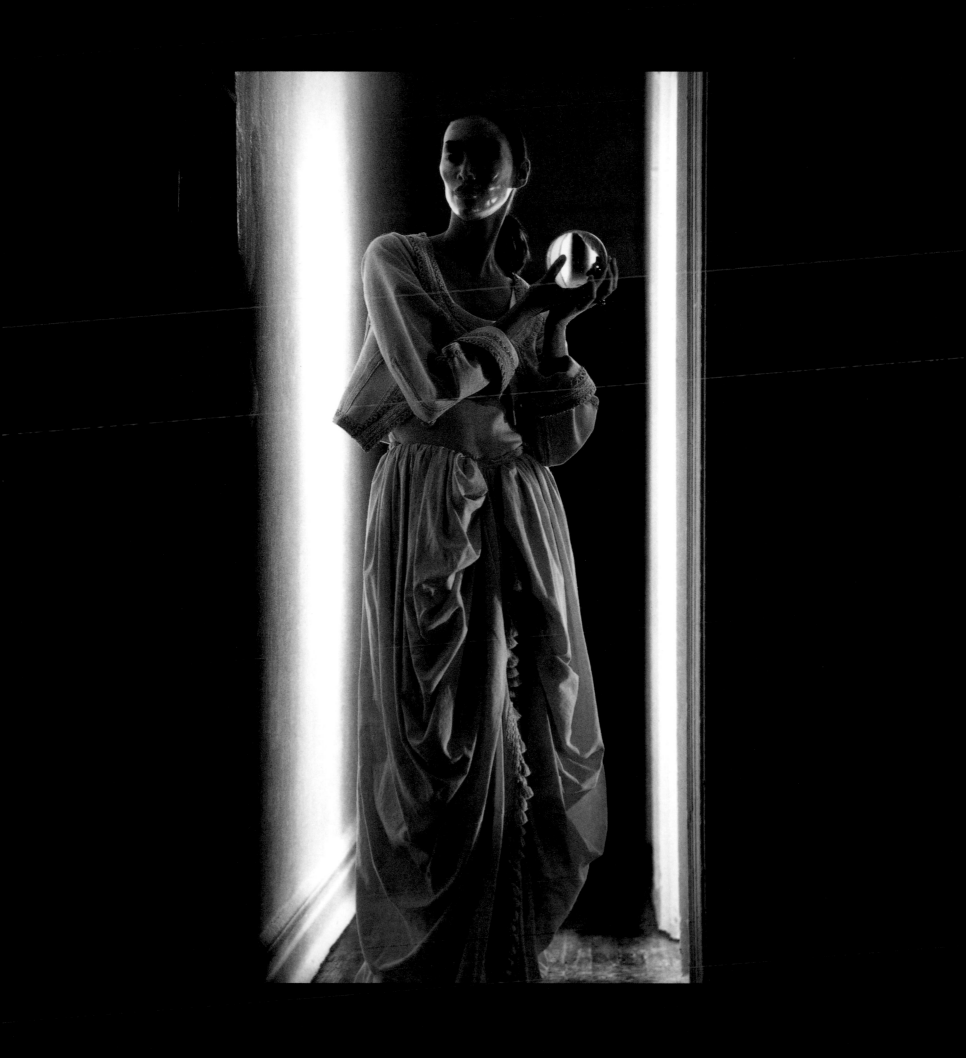

MEBABEL
Protector of the Innocent

DERDEKEA
Angel of the Salvation of Man

CANELOAS
Most Holy Angel

ACHSAH
Angel of Benevolence

CHRYSOSTOM
Angel of Ascension

MY SPIRIT TRIED TO LEAVE ME, 1994
John Dugdale

MALKIYYAH
Angel of Blood

RAM KHASTRA
Angel of the Sound

AMITIEL
Angel of Truth

DURBA'IL
Angel of Exorcism

SIRUSHI
Angel of Announcements

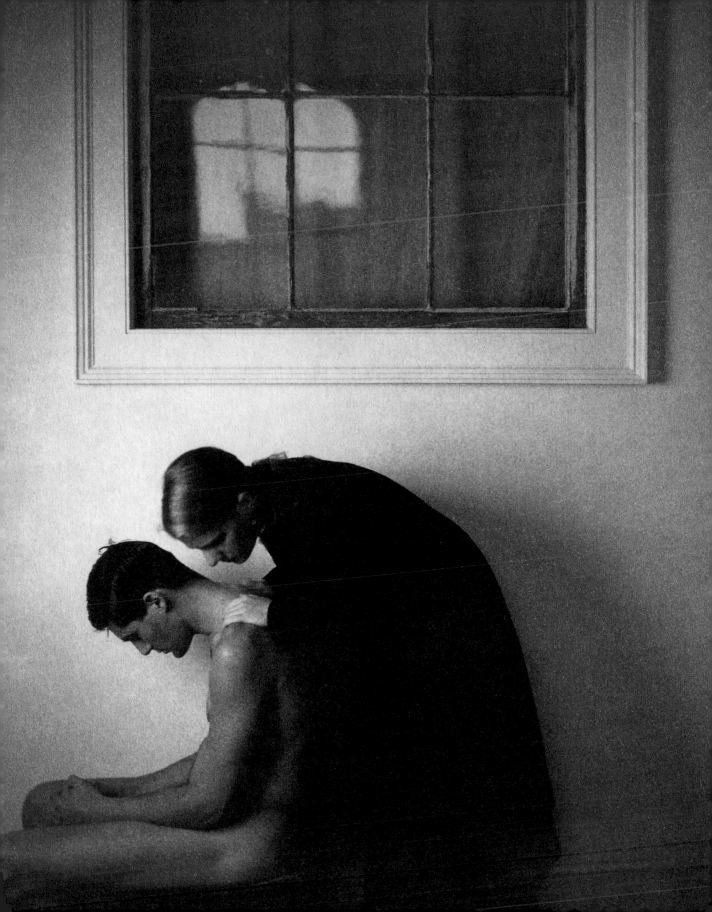

DEMIURGE
Architect of the Universe

SEGEF
Angel of Destruction

ASRAFIL
Angel of the Last Judgment

TZARMIEL
Angel Guard of the North Wind

SANASIEL
Angel Who Stands at the Gate of Life

UNTITLED
Frank W. Ockenfels 3

ZERACHIEL
Angel Who Keeps Watch

IELAHIAH
Angel Who Renders Decisions in Legal Suits

ANAUEL
Angel of Commission Brokers

BESHTER
Angel of Sustenance

ELORKHAIOS
Angel of the Secrets of Creation

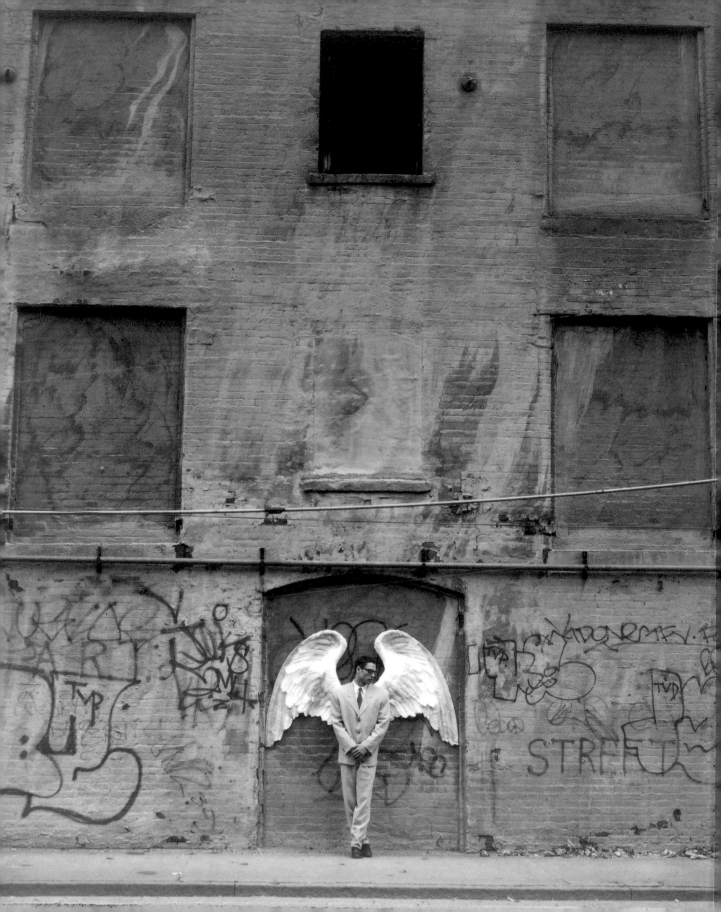

ELOA
Angel Born of a Tear Shed by Jesus

GAZARDIEL
Angel Who Kisses the Prayers of the Faithful

AKER
Angel of the End of the World

FAVASHI
Guardian Angel of Believers

PHANUEL
Angel of Hope

ANGEL OF SARAJEVO, 1995
Gary Isaacs

KABSHIEL
Angel of Grace and Power

ZADKIEL
Angel of Benevolence and Mercy

VEHUIAH
Angel of Prayers

MAADIM
Angel of Warmth

MEHER
Angel of Light and Justice

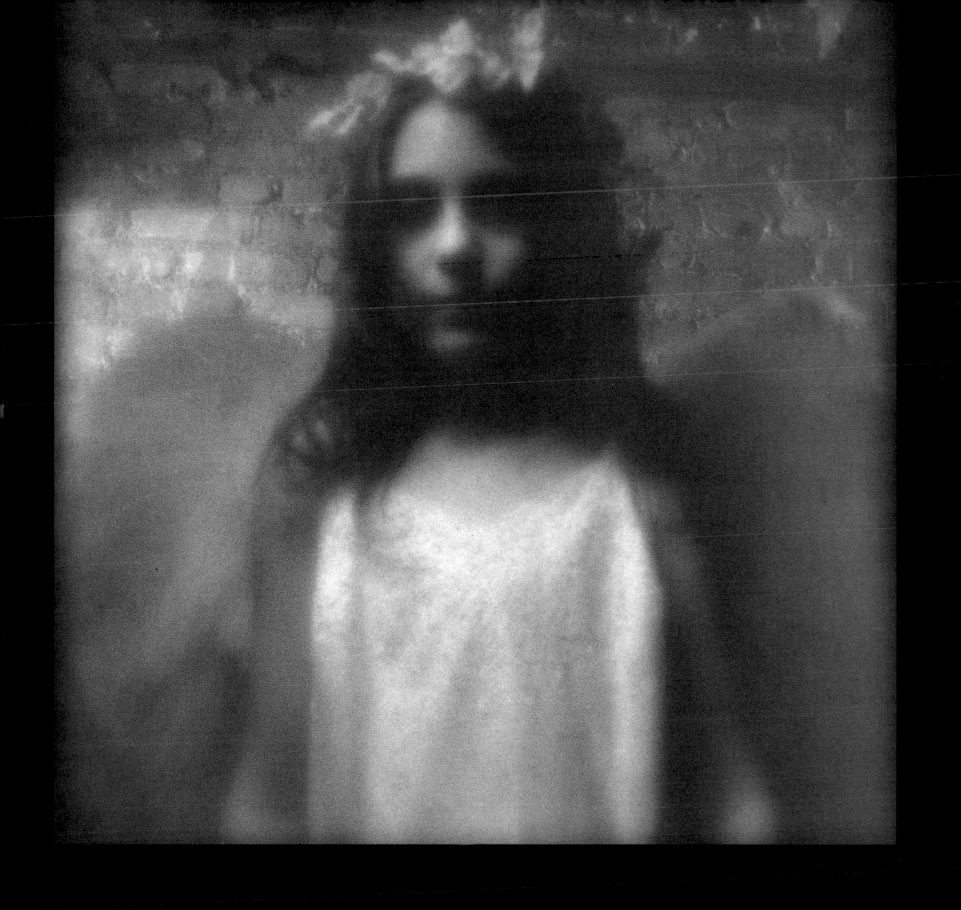

MIKHAR
Angel of the Waters of Life

SALMAY
Angel of Magic

JELIEL
Angel of Passion

GEVIRIRION
Angel of Strength

ADNACHIEL
Angel of Sagittarius

THE MESSENGER, 1993
Christina Hope

NOGUEL
Angel of Venus

DAGIEL
Angel of Fish

PHARZUPH
Angel of Lust

JAZAR
Angel Who Compels Love

SACHIEL
Angel of the Eleventh Hour, Saturday Night

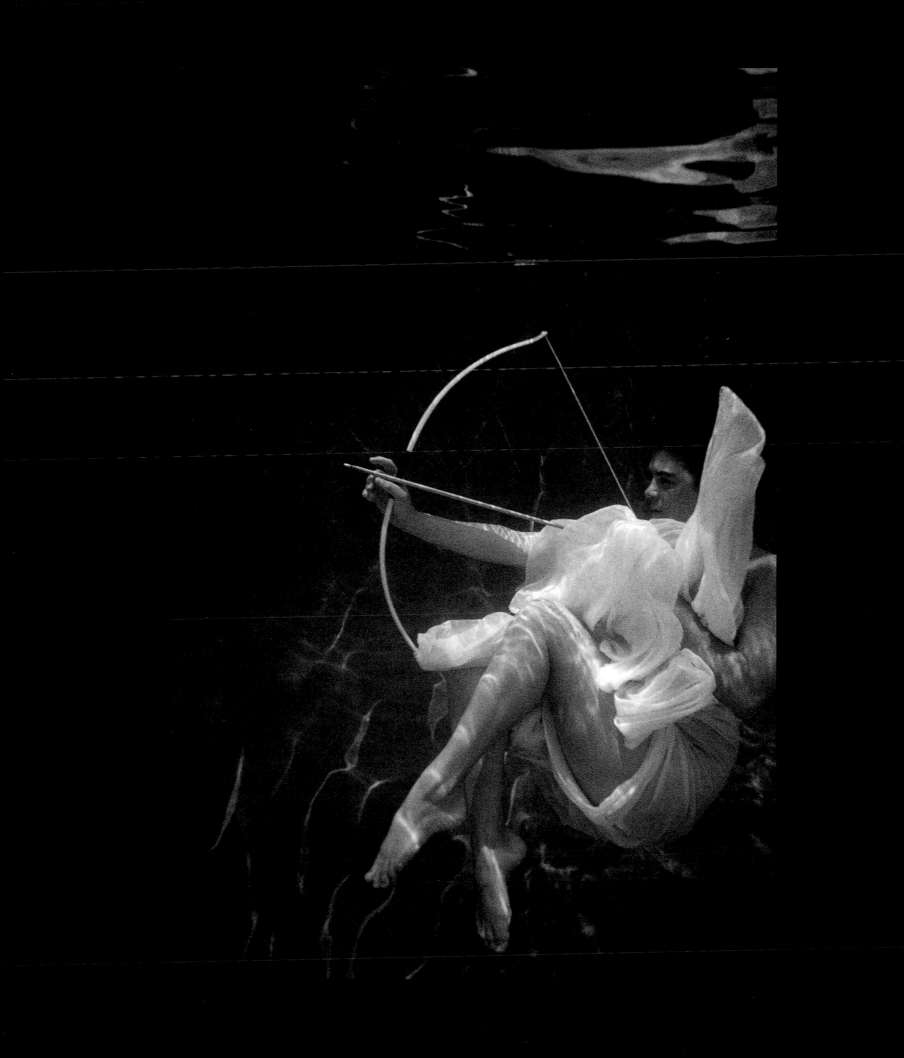

ZABESAEL
Angel of the Seasons

DEALZHAT
Angel Who Made the Sun Stand Still

OTHEOS
Angel of Discovered Treasure

HASDIEL
Angel of Benevolence

MESSIAH
Angel of the Garden of Eden

MISTY DAWN, NORTHERN CALIFORNIA
Jock Sturges

RAHTIEL
Angel Who Names the Stars

SHAMSIEL
Angel of Daylight

GRANIEL
Angel of the Second Hour

MURIEL
Angel of June

GURID
Angel of the Summer Equinox

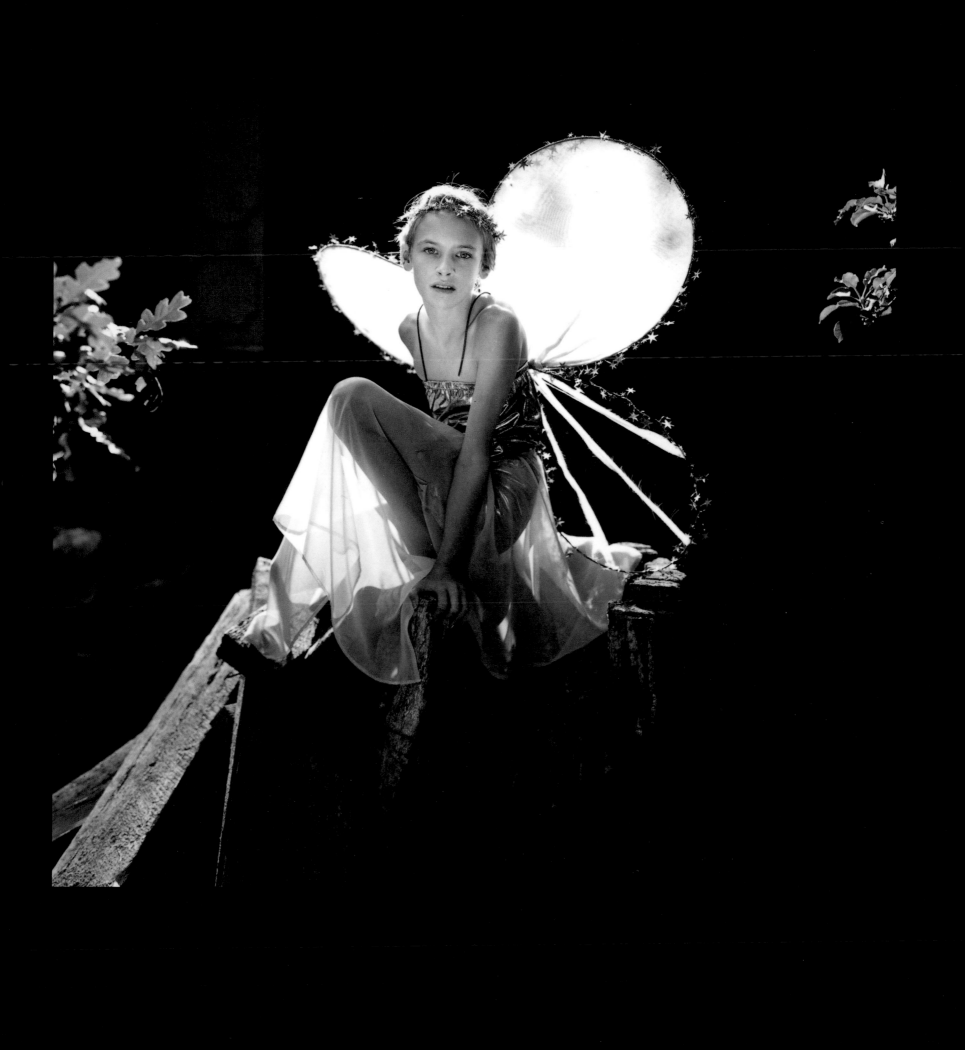

LILITH
The First Temptress

DUMA
Angel of Silence

PLESITHEA
Mother of Angels

TEZALEL
Angel of Marital Fidelity

PISTIS SOPHIA
Procreator of the "Superior Angels"

GIRL IN BLACK CHIFFON, PHILADELPHIA, 1988
George Holz

AMALIEL
Angel of Chastisement

MORDAD
Angel of Death

ANAEL
Angel Ruler of the First Hour of Night

TORQUARES
Angel of Autumn

ACIEL
Angel of the Underworld

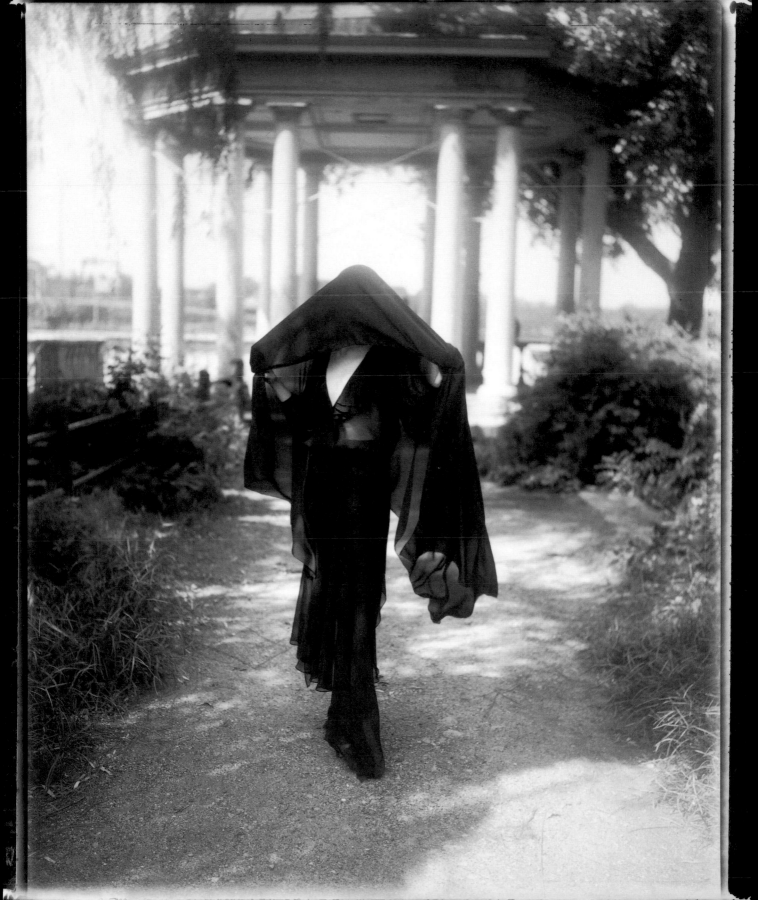

FARUN FARO VAKSHUR
Protecting Angel of Mankind

AUPIEL
Tallest Angel in Heaven

HAAMIAH
Protector of the Seekers of Truth

TEMPERANCE
Angel with the Sign of the Sun

SANDALPHON
Angel of Glory

UNTITLED
Cheryl Koralik

METATRON
Angel of Sustenance

TABRIS
Angel of Free Will

ABEL
Angel Present at the Soul's Judgment

MALACH HA-SOPHER
Angel of the Silence of Death

PEDAEL
Angel of Deliverance

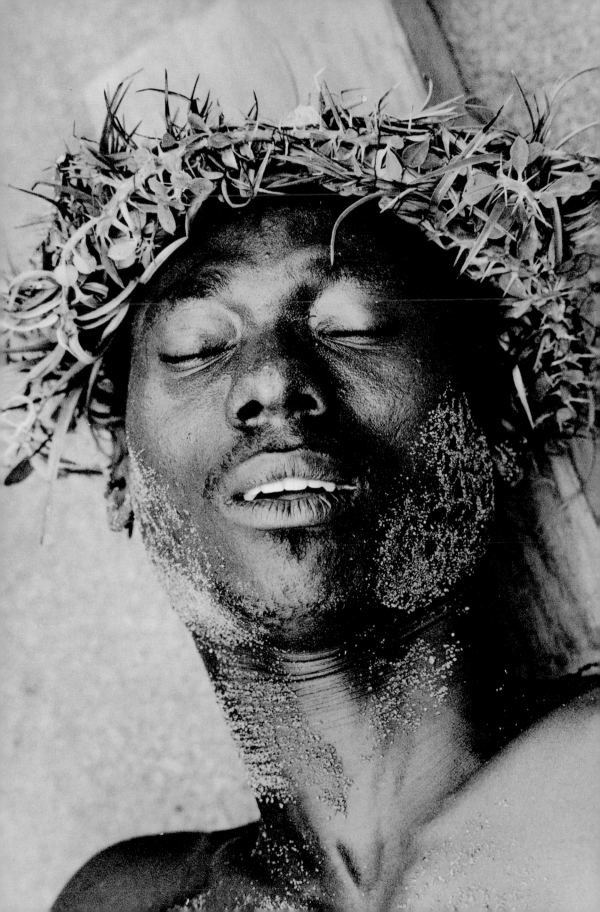

TEBLIEL
Angel with Dominion over the Earth

SADRIEL
Angel of Order

SORUSH
Angel of Judgment

COLOPATIRON
Angel Who Sets Prisons Open

VASIARIAH
Angel of Justice

NO OIGO, NO VEO...ME CALLO, 1997
Daniel Hernández

MEHIEL
Angel of Orators

ZADA
Angel Invoked in Conjuring

MORAEL
Angel of Invisibility

CEDRION
Angel of the South

NATTIG
Protecting Angel

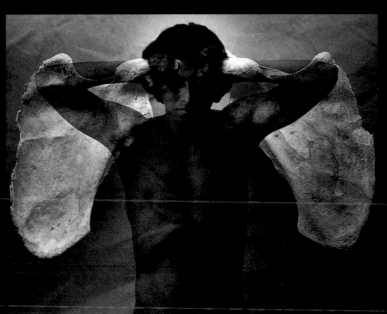

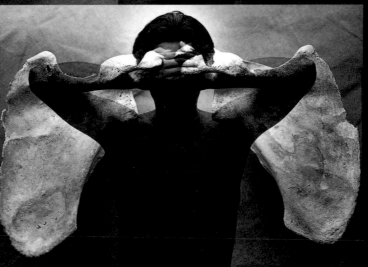

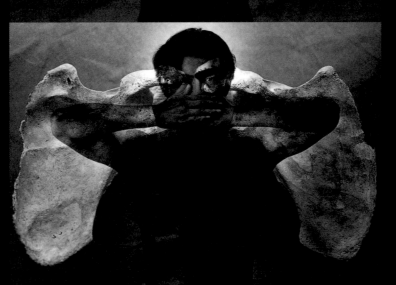

POTEH
Angel of Forgetfulness

LIFTON
Guard of the Seventh Heavenly Hall

LIBRABIS
Angel of Hidden Gold

SEMJAZA
Angel Teacher of Enchantments

SANGARIEL
Guard of the Portals of Heaven

EL ANGEL SALVAJE
Josephine Sacabo

SALATHIEL
Angel of Repentance

IAQWIEL
Angel of the Moon

AFTIEL
Angel of Twilight

ARURU
Angel Who Created Man from Clay

QALBAM
Guard of the Gates of the South Wind

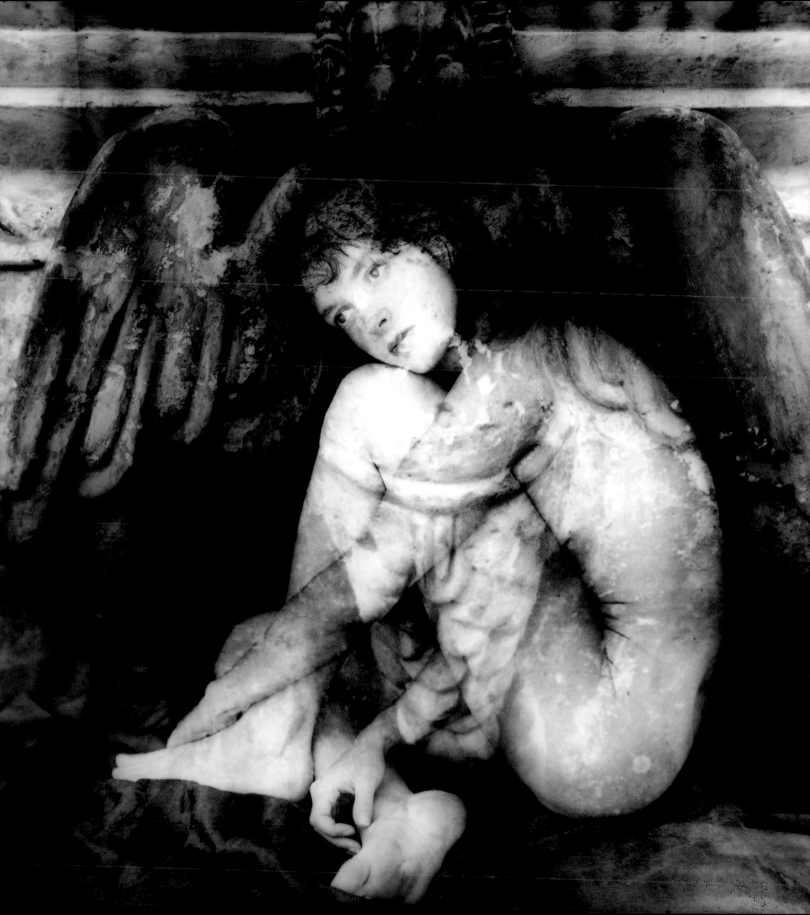

ETRAPHILL
Judgment-Day Trumpeter

HERMESIEL
Leader of the Heavenly Choir

SALILUS
Angel Who Opens Sealed Doors

MZPOPIASAIEL
Leader of the Angels of Wrath

SHEMAEL
Angel of Heavenly Song

THE CROSSING, 1995
Christina Hope

JEHOEL
Singer of the Eternal

TAGAS
Angel Conductor of Choirs

BAHRAM
Angel of Victory

MUNKAR
Angel Who Wakes the Dead

NARIEL
Angel of the Noonday Winds

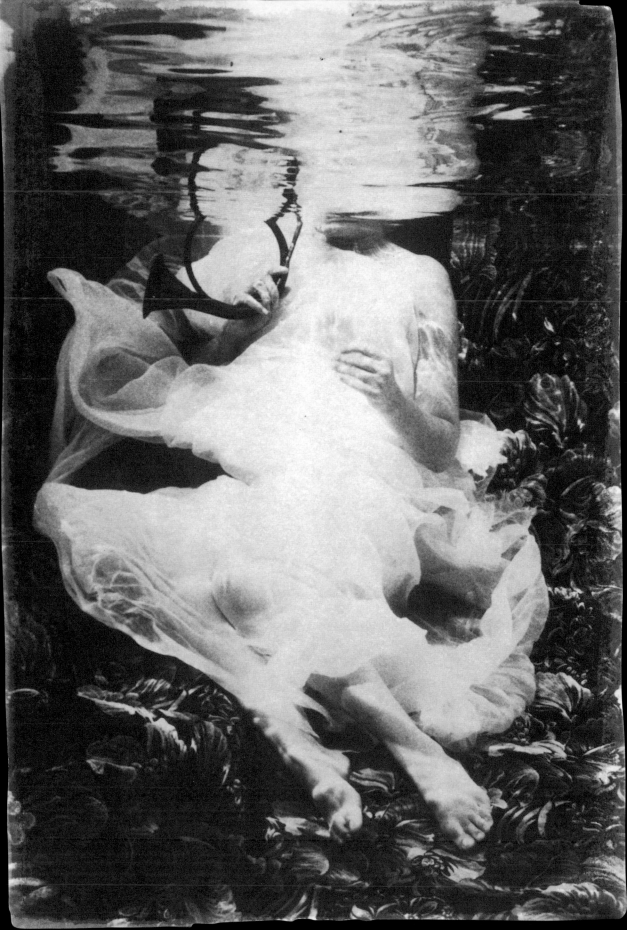

IURABATRES
Angel of Venus

PORNA
Angel of Friday

ADNAI
Angel of Pleasure

HSHAHSHIEL
Spellbinding Angel

NITIKA
Angel of Precious Stones

RUNWAY ANGEL, 1984
Just Loomis

EXAEL
Angel of Perfumes

SOQED HOZI
Angel of the Balances

NECIEL
Angel of the Moon

AZAZEL
Angel of Ornaments

SIALUL
Angel of Prosperity

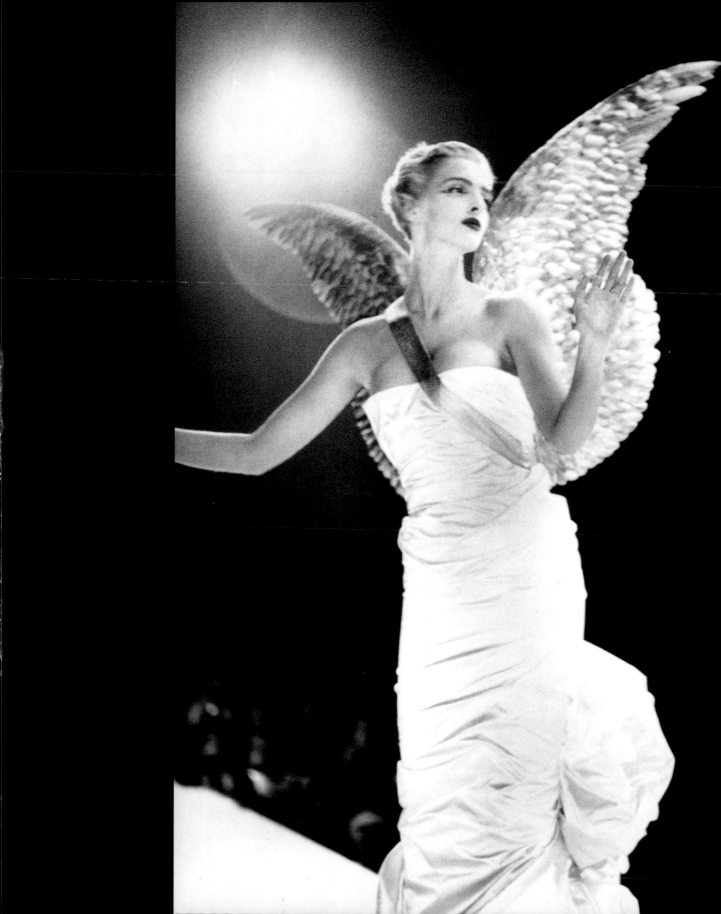

MICHAEL
Prince of Light

JEHUDIEL
Ruler of the Movements of Celestial Spheres

SILA
Angel of Power

KARNIEL
Guard of the Gates of the West Wind

KAFZIEL
Angel Governing the Death of Kings

UNTITLED
Giacomo Bianco

ADIRIRON
Angelic Chief of the Might of God

HUTRIEL
Angel of Punishment

YROUEL
Angel Protector of Pregnant Women

NUDRIEL
Angelic Guard

GEBURATHIEL
Angel Steward of the Seventh Heaven

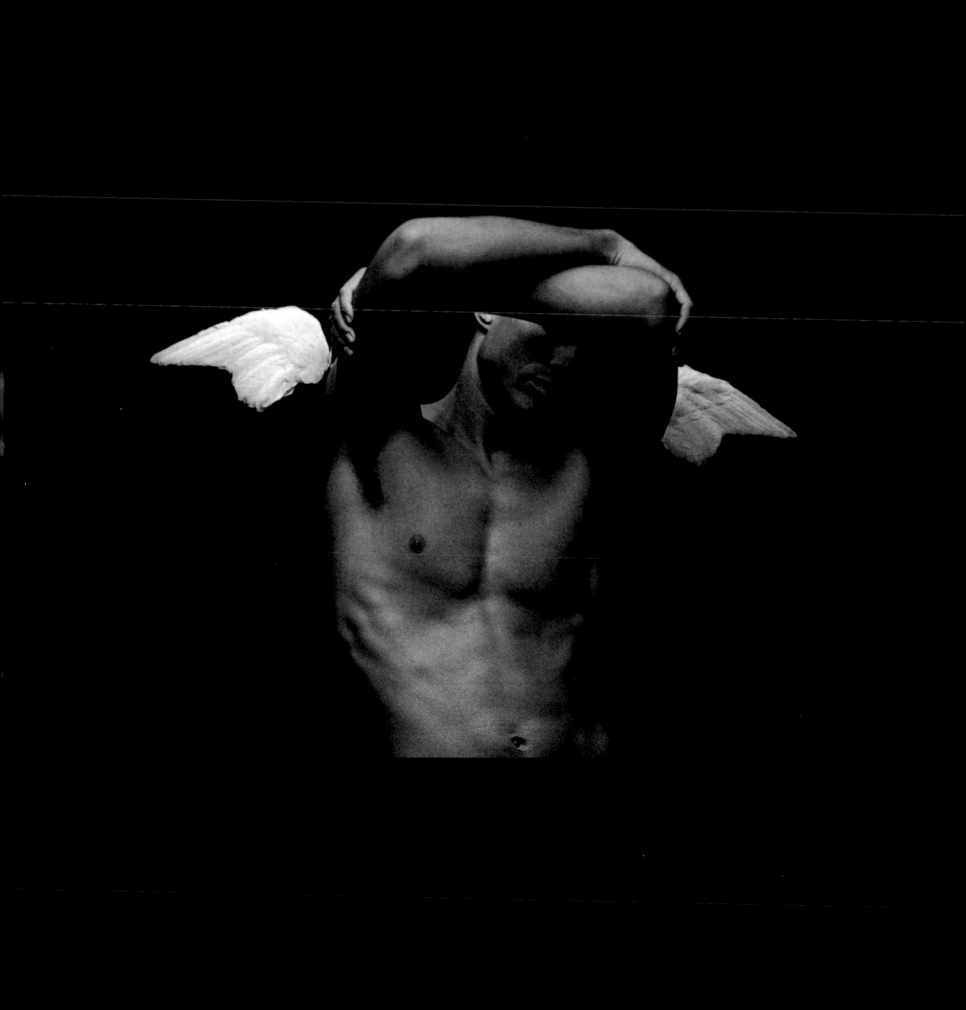

RAMPEL
Angel of Mountain Ranges

AMET
Angel of the Sun

MACHAL
Angel Invoked to Exorcise Bats

NDMH
Angel of the Summer Equinox

DONACHIEL
Angel Who Commands Demons

TONY, WOODLAND VALLEY, 1988
George Holz

VARCHIEL
Angel of Leo

BEHEMIEL
Angel of Tame Animals

YURA
Angel of Rain

HAILAEL
Angel of Holy Beasts

UBAVIEL
Angel of Capricorn

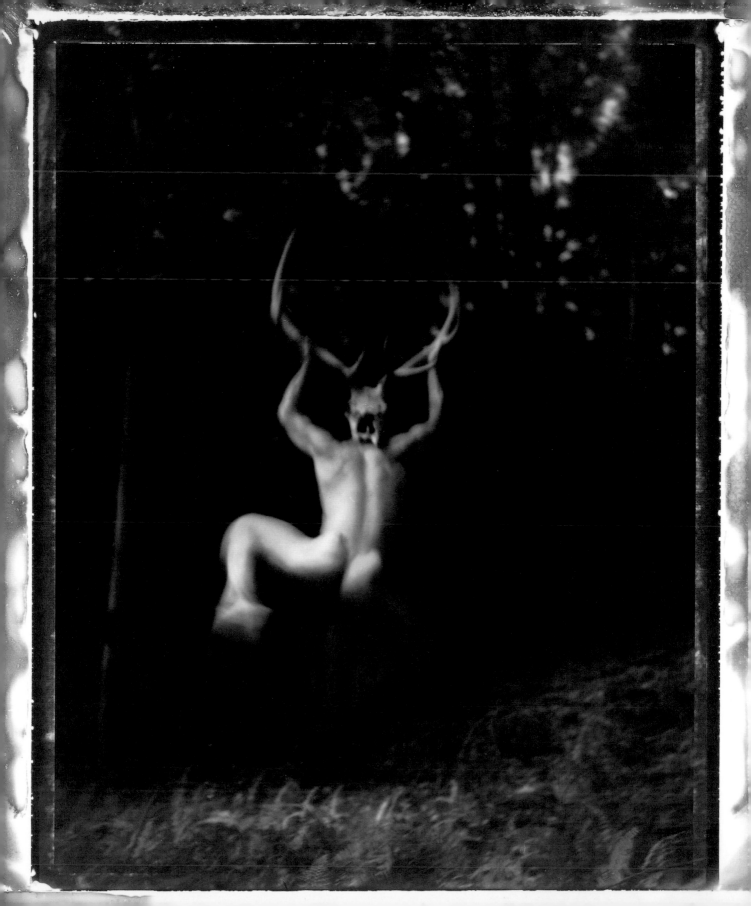

BABHNE'A
Angel Who Protects against Evil

CHUSIEL
Angel of the South Wind

PTHAHIL
Angel of the Lesser Stars

SHEDU
Protecting Angel

ANPIEL
Angel of Birds

REMINDING MYSELF, 1995
Karen Graffeo

LAMA
Angel of the Air

ASMODEL
Angel of April

SITAEL
Angel Invoked to Overcome Adversity

EREMIEL
Angel of the Underworld's Souls

IAEO
Angel Who Exorcises Demons

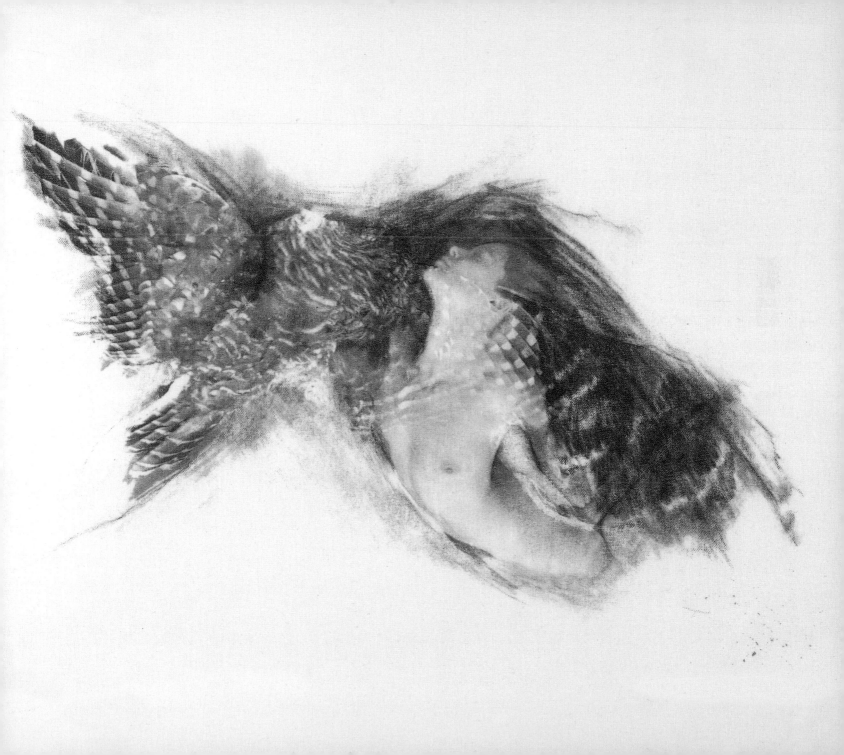

AFRIEL
Angel of Force and Power

SARGOLAIS
Angel Protector of Friendship

PHALGUS
Angel of Judgment

GABRIEL
Angel of Aspirations and Dreams

ZIKIEL
Angel of Comets

EARTH ANGELS, 1996
Elizabeth Opalenik

JALUHA
Angel Bearer of the Cup of Oblivion

DOKIEL
Guardian of the Hall of Heaven

PURAH
Angel of Oblivion

MIBI
Ministering Angel

HARSHIEL
Angel of Spells

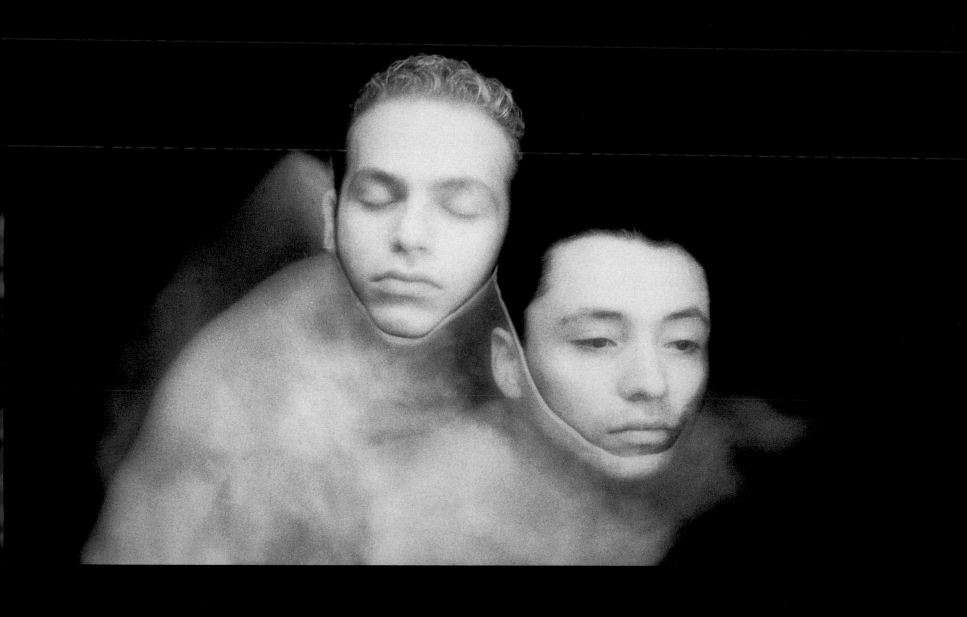

ADERNAHAEL
Angel Who Cures Colic

ZACHRIEL
Angel of Memory

VELOAS
Most Pure Angel of God

REHAEL
Angel of Parental Respect

ZAHARI'IL
Angel of Childbirth

#21 KIKI AND TRISTAN, 1994
Sandi Fellman

AMHIEL
Angel Who Wards Off Evil

KIDUMIEL
Protector of Newborns

MAHARIEL
Provider of New Souls

TAHARIEL
Angel of Purity

KIRTABUS
Angel of Languages

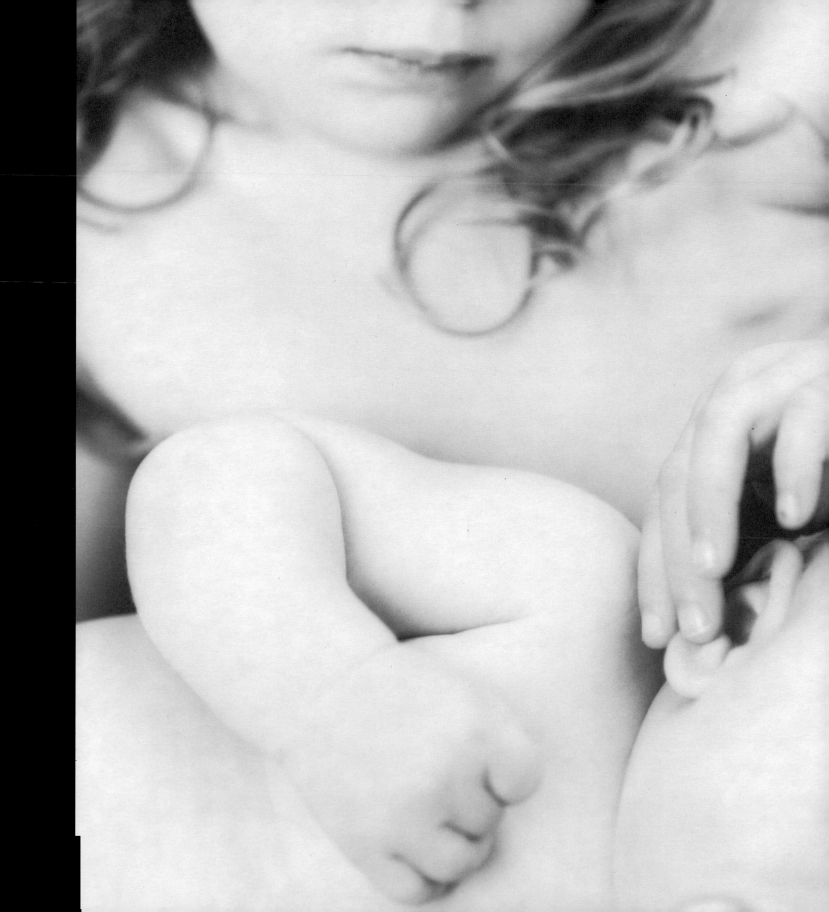

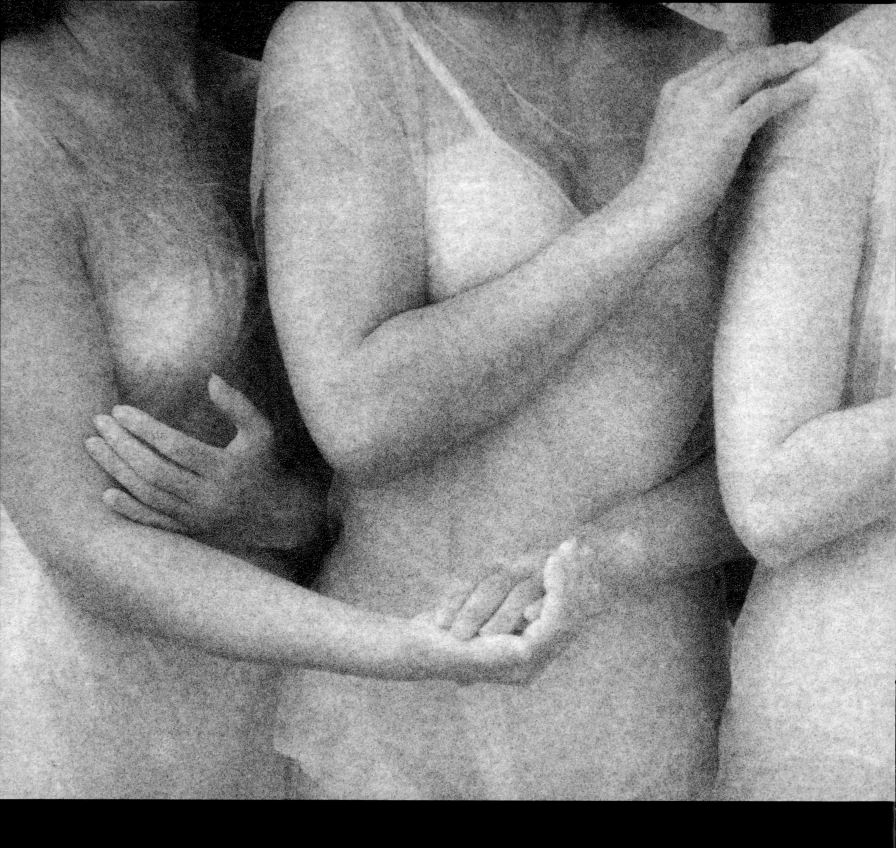

EVE

Angel of Humanity

SASNIGIEL

Angel of Wisdom

HEKALOTH

Angel of Heavenly Paradise

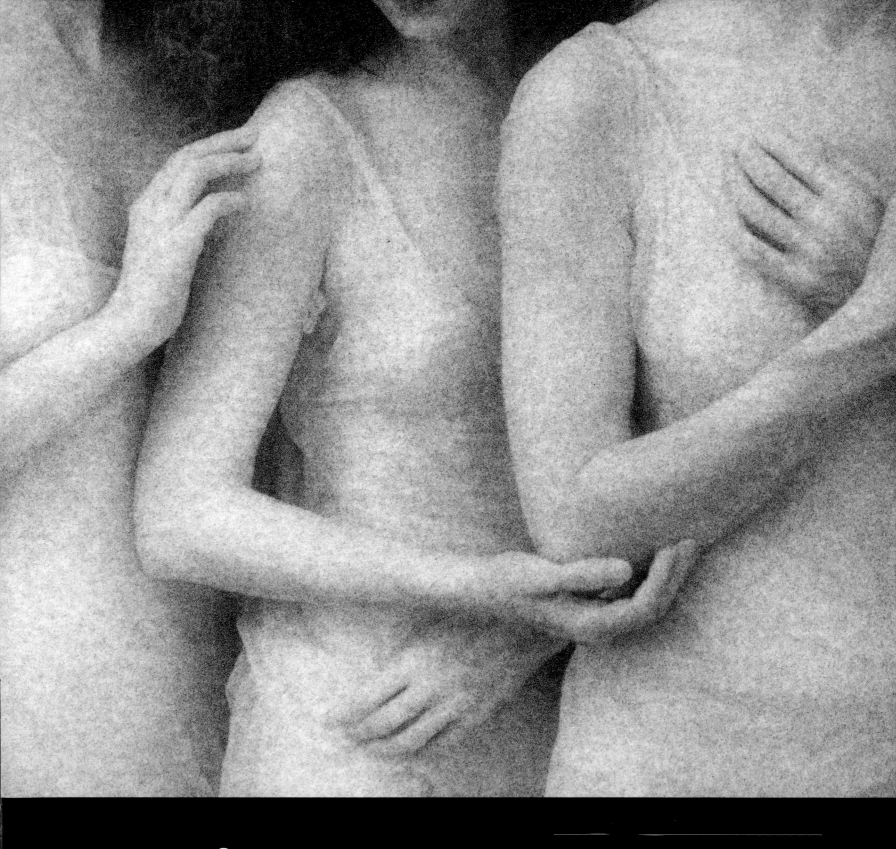

ORANIR ISADORA DUNCAN DANCERS, 1996

RAHMIEL
Angel of Mercy

NARSINHA
Angel of Heroism

MIZUMAH
Angel of Faith

SAKRIEL
Porter of Heaven

TSADKIEL
Angel of Justice

EL ANGEL, 1989
Luis Gonzalez Palma

CHOSNIEL
Angel of Open Hearts

ROCHEL
Angel of Lost Objects

AMERATAT
Angel of Immortality

NAREL
Angel of Winter

URIRON
Angel Protector Against Sudden Death

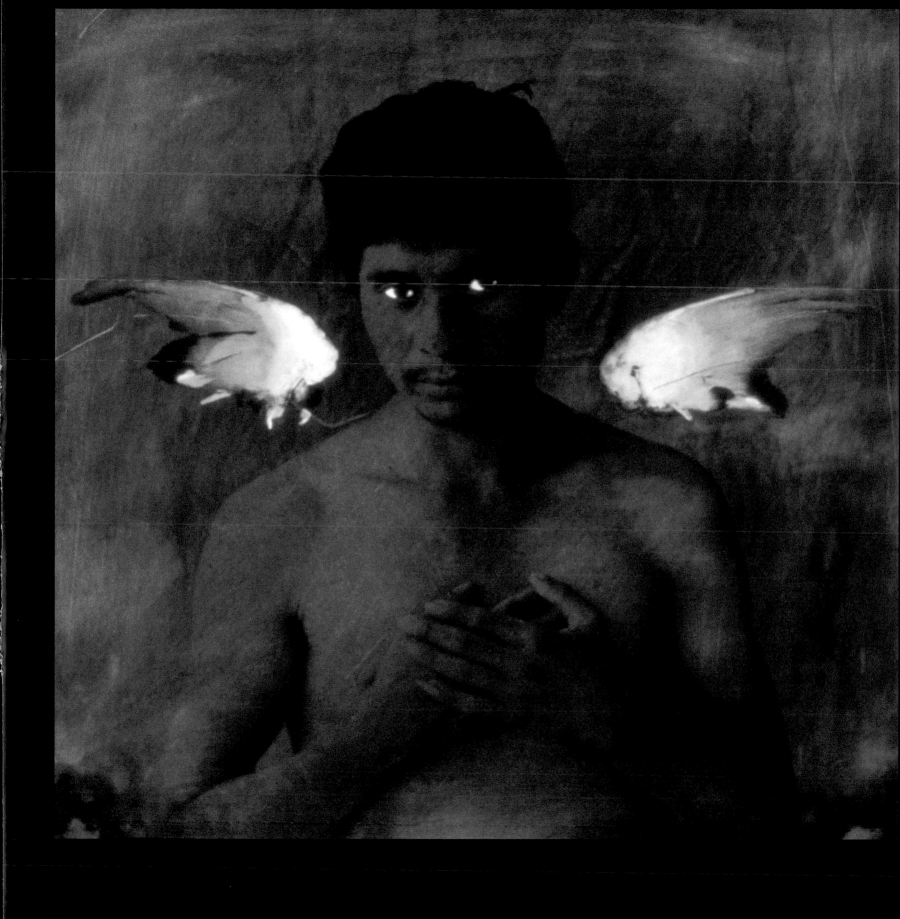

ZAAMAEL
Angel of Storms

KAKABEL
Angel of the Constellations

UMABEL
Angel of Astronomy

MANAKEL
Angel of Aquatic Animals

NITIBUS
Angel of the Stars

UNTITLED
Jerry N. Uelsmann

HAMAL
Angel of Water

PARVARDIGAR
Angel of Light

GAMBIEL
Angel of Aquarius

RAHAB
Angel of the Sea

RABDOS
Angel Who Stops the Stars

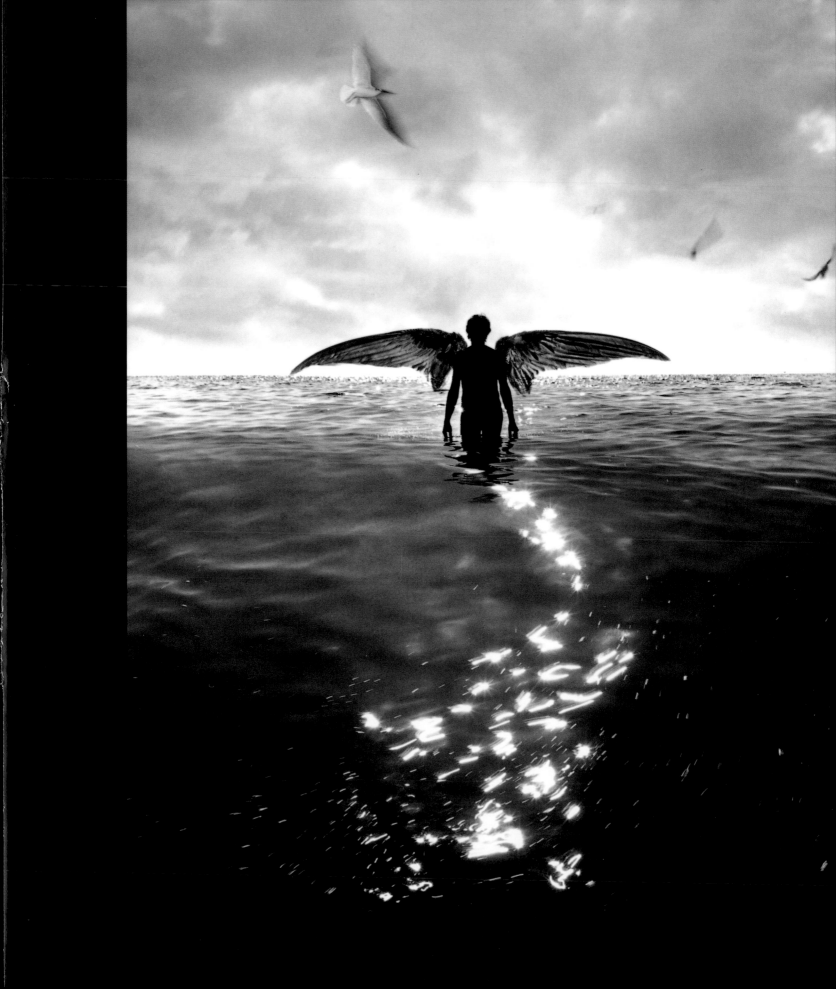

AELUN
Angel of Lightning

SERUF
Angel of Fire

EMMANUEL
Angel of the Fiery Furnace

GARZANEL
Angel Who Wards Off Evil

HADRIEL
Porter of Heaven's Second Gate

ANGEL
Duane Michals

HASMED
Angel of Annihilation

MEBAHIAH
Angel with Dominion Over Morals

GALGALIEL
Chief Angel of the Wheel of the Sun

AZBOGAH
Angel Who Heals All Hurt

SHINIAL
Angel Warden of the Seven Celestial Halls

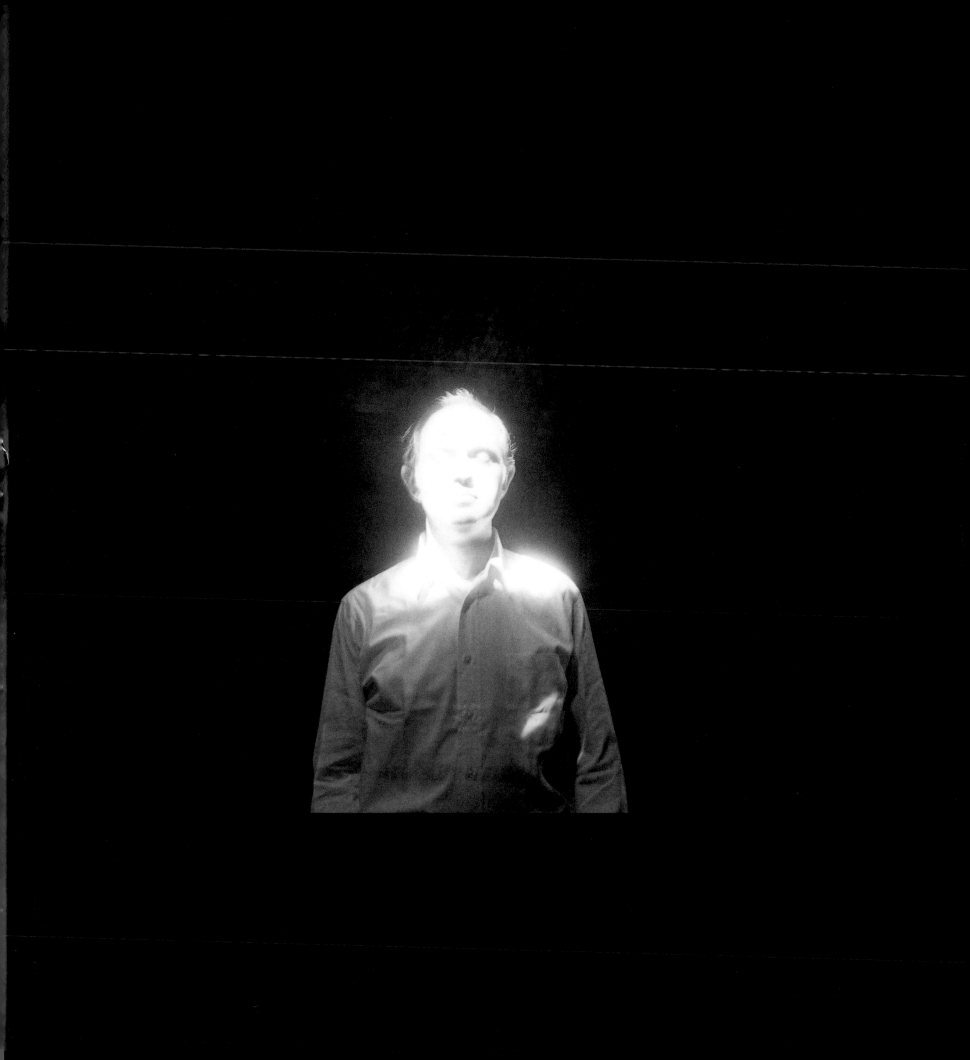

TUBIEL
Angel Who Returns Small Birds to Their Owners

ZAZRIEL
Angel of Divine Strength, Might, and Power

ARPHUGITONOS
Angel of the End of the World

CLARENCE ODDBODY
The Probationary Angel

HEMAN
Angel of the Morning Choir

UNTITLED
Cheryl Koralik

TIR
Angel of June

ABRID
Angel of the Summer Equinox

DJIBRIL
The Faithful Spirit

ZLAR
Angel of Secret Wisdom

GAMIDOI
A Most Holy Angel

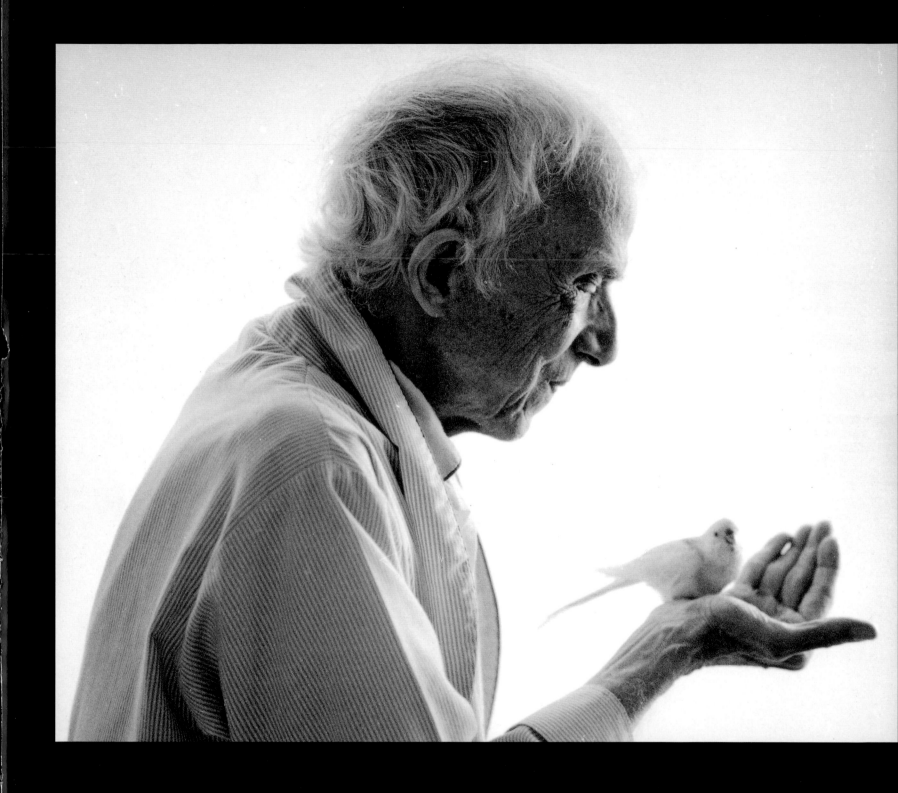

THE PHOTOGRAPHERS

AUDREY BERNSTEIN

12 Southlawn Avenue, Dobbs Ferry, NY 10522
Tel: (914) 693-4189. Fax: (914) 674-9822

GIACOMO BIANCO

Milan, Italy

ANDREW BRUCKER

225 Central Park West, #1219, New York, NY 10024
(212) 724-3236

RICHARD DI NOME

6134 Liebig Avenue, Riverdale, NY 10471
(718) 549-6406
Represented by Bill DiNome/Debra Flora
Tel/fax: (910) 762-9073

JOHN DUGDALE

John Dugdale, born in 1960, lives and works in
New York City and in the Catskills. His work is
included in the collection of the Metropolitan
Museum of Art and the Houston Museum of Fine
Arts. He is represented by the Wessel + O'Connor
Gallery, 242 West 26th Street, New York, NY
10001, (212) 242-8811.

SANDI FELLMAN

548 Broadway, #4E, New York, NY 10012
(212) 925-5187. Represented by Edwynn Houk
Gallery, New York (212) 750-7070. Sandi's work
has been exhibited internationally and is in the
permanent collection of the Metropolitan Museum
of Art, the Museum of Modern Art, Bibliothèque
Nationale (Paris), and many other public and
private collections.

KAREN GRAFFEO

Stare Studio.
2403 2nd Avenue N., Birmingham, AL 35203.
Tel: (205) 252-6787. Fax: (205) 252-1375

LOIS GREENFIELD

52 White Street, New York, NY 10013
Tel: (212) 925-1117. Fax: (212) 925-1161
E-mail: LBG000@aol.com

KELLY GRIDER

100 West 79th Street, New York, NY 10024
Couturier Gallery, Los Angeles (213) 933-5557
E-mail: luthercat@earthlink.net

CHUCK HENNINGSEN

239 Morada Lane, Taos, NM 87571
(505) 758-7282. Represented by
Lumina Fine Art and Photography

DANIEL HERNÁNDEZ

Represented in the USA by arteBELLO,
fax: (413) 586-8556, e-mail: artebello@aol.com
Represented in Guatemala by ORFEO,
Tel: (502) 232-7533. Fax: (502) 220-4666
E-mail: orfeo@infovia.com.gt

GEORGE HOLZ

666 Greenwich Street, #1060, New York, NY 10014.
Tel: (212) 229-0017. Fax: (212) 229-0019.
Represented by Fahey Klein Gallery,
Los Angeles, CA (213) 934-2250 and
Staley-Wise Gallery, New York, NY (212) 966-6223

CHRISTINA HOPE

2720 Third Street South, Jacksonville Beach, FL 32250
Tel. (904) 246-9689. Fax: (904) 246-7492

GARY ISAACS

Denver, Colorado

CAROLYN JONES

New York City, (212) 431-9696
Represented by Barbara Von Schreiber,
(212) 460-5000

DAVID MICHAEL KENNEDY

Santa Fe, NM, (505) 473-2745. Represented by
Andrew Smith Gallery, Santa Fe, NM,
(505) 984-1234; The Gallery at Katonah General
Store, Katonah, NY, (914) 232-6400, and
Hackelbury Fine Art, London, England,
tel: 44-171-3761011. David has been working
exclusively in the Palladium process for the past 12
years. He accepts limited assignment work and is
currently working on a new dance portfolio of the
Lakota Sioux.

CHRISTINE KIEBERT-BOSS

Represented by John Stevenson at Photography:
Platinum Gallery, New York, NY.
The pinhole photograph "Hanna Rose III" was
originally produced for the book *Hanna Rose and
Her Broken Angel Wing* by Maggie Norris and
Rachel P. Abramovitz.

FOR VISIONS OF ANGELS

CHERYL KORALIK

226 W. 72nd Street, Apt. 1C, New York, NY 10023
(212) 877-5922

JACK R. LINDHOLM

131 Chrystie St., New York, NY 10002
Tel: (212) 274-0466. Fax: (212) 226-1731

MARCIA LIPPMAN

220 E. 63 St., New York, NY 10021
Tel: (212) 832-0321. Fax: (212) 644-0090
Represented in New York City by
Staley-Wise Gallery and in Los Angeles
by Paul Kopeikin Gallery.

BLAKE LITTLE

6442 Santa Monica Blvd., #201, Los Angeles, CA
90038 (213) 466-9453. The photograph "Fernando
with Wings" is from the book *Dichotomy*, State of
Man Publishing, 1996. Represented by Wessel +
O'Connor Gallery, 242 W. 26th St., New York, NY
10001, (212) 242-8811.

JUST LOOMIS

(310) 589-2670.
Represented by Michele Karpé, (818) 760-0491
Film agent: Stephan Fruth, Neue Sentimental Film,
Hamburg, Germany, tel: 49-40-43 18 690.

DUANE MICHALS

109 East 19th Street, New York, NY 10003
Represented by the Sidney Janis Gallery, New York.
His work is included in most major
museum collections.

FRANK W. OCKENFELS 3

Represented by Carol LeFlufy at
Art & Commerce, NYC.

ELIZABETH OPALENIK

5921 Chabot Crest, Oakland, CA 94618.
Tel/fax: (510) 652-6414. Represented by
Robert Mead Associates, (914) 835-0680

LUIS GONZALEZ PALMA

Luis Gonzalez Palma was born in 1957 in
Guatemala, where he lives and works. His work
is included in the collections of the Art Institute
of Chicago; LA County Museum; New Orleans
Museum of Art; North Dakota Museum of Art;
Fine Arts, Houston; and the Minneapolis Museum
of Art, among others. He is represented in the U.S.
by Schneider Gallery, Chicago, IL.

JOSEPHINE SACABO

716 Gov. Nicholls St., New Orleans, LA 70116
Represented by A Gallery for Fine Photography,
New Orleans; Galerie Guillon-LaFaille, Paris; and
Akehurst Bureau, London.

DAVID SEIDNER

David Seidner lives and works in New York and
Paris. His work appears in many magazines, most
notably *Vanity Fair* and *The New York Times
Magazine*. He has exhibited internationally, and will
have a retrospective in the year 2000 at the Maison
Européenne de la Photographie in Paris.

LISA SPINDLER

2900 E. Jefferson, Detroit, MI 48207
(313) 393-8538. Represented by Melanie
Johns-Secreto, Room with a View, Royal Oak, MI.

ROBERT STIVERS

Robert Stivers (b. 1953) has shown his work exten-
sively in the United States and Europe. His pho-
tographs are in the collections of the Los Angeles
County Museum of Art, the Museum Ludwig, and
The Victoria and Albert Museum. The artist
currently lives and works in Santa Fe, NM. His
monograph, *Robert Stivers: Photographs* is available
through Arena Editions, 1 (888) 759-4851.

JOCK STURGES

Courtesy of Thomas Meyer Fine Arts, San Francisco
Tel: (415) 386-1225

JOYCE TENNESON

Tel: (212) 741-9371. Fax: (212) 675-3378

JERRY N. UELSMANN

5701 SW 17th Drive, Gainesville, FL 32608
Tel: (352) 372-1746. Fax: (352) 377-1133

JAMES WHITE

James White is a photographer who began his
career in Italy and now resides in New York City.
His fashion and celebrity work has appeared in
publications throughout the world. He is
represented by the agency, nyc.

JOHN WIMBERLEY

John Wimberley has been making photographs
for more than thirty years. For more information,
phone (650) 323-4301.

THANKS & ACKNOWLEDGMENTS

➤ The many gifted artists who so generously
submitted work for this book

➤ Marta Hallett for her unfailing belief

➤ Those who provided us with help, inspiration
and encouragement along the way:
Elizabeth Viscott Sullivan and Tricia Levi,
along with the rest of the staff at Smithmark;
Susan Kushnick; and Eva Klein, who made the connection.

➤ Gustav Davidson for his incredible reference work
A DICTIONARY OF ANGELS

➤ I thank Karen Engelmann for being at my side from the start,
for her ideas, glorious talent, and humor;
Andrew Ramer for knowing angels so well;
Nina Reznick for treating this project with such love and integrity;
and to the voice of inspiration, wherever it came from,
for instructing me to create Visions of Angels. —NB

➤ Many thanks to (and for): Nelson —creative, inspiring, and
generous collaborator, and a person filled with the real stuff of Life;
Seth Godin for helping me enter the world of books;
Martha Ann, Mindy, and Snježana, who keep me afloat;
Sylvia, my housewarmer; and Ann, mijn Belgishe engel. —KE

*A portion of the royalties from this book
will benefit organizations dedicated to the
battle against AIDS.*

DEDICATIONS

This book is dedicated to the scores of angels that
have flown from this earth far too soon, especially
Steven, Travis, and Jeffrey; and also to those
that are with me still, including my mother, Sophia,
and to Paul, my beloved partner.

—NELSON BLONCOURT

For Lilly & Ántonia, who opened for me
the creative gateway, and Erik,
who urges me to walk that path daily.

—KAREN ENGELMANN

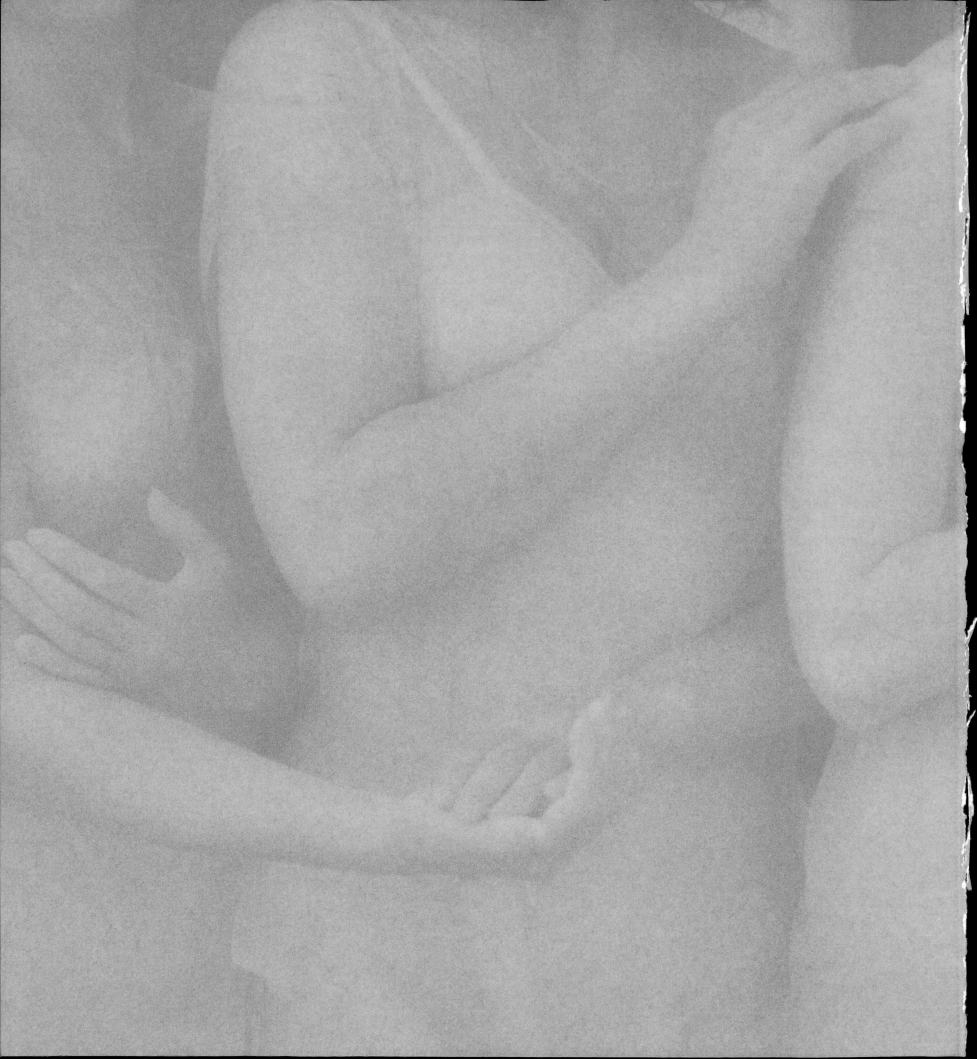